THE HOUSE OF GLAM

LUSH INTERIORS
&
DESIGN
EXTRAVAGANZA

gestalten

A FEAST FOR THE EYES

INTRODUCTION BY CLAIRE BINGHAM
Pages 4–11

PROFILE
CRISTINA CELESTINO

ITALY
Pages 12–23

ESTER'S APARTMENT 2.0

BERLIN, GERMANY
Pages 24–31

PALERMO UNO

ITALY
Pages 32–37

TRIBECA LOFT

NEW YORK CITY, USA
Pages 40–45

THE SHOE FACTORY

NORTHEAST ITALY
Pages 46–53

COLOR

MOSCOW, RUSSIA
Pages 54–59

TEOREMA MILANESE

MILAN, ITALY
Pages 62–71

MOSCOW MULTI-STORY

MOSCOW, RUSSIA
Pages 72–75

PROFILE
DAVID ALHADEFF

USA
Pages 76–87

PARKER PALM SPRINGS

PALM SPRING, USA
Pages 88–95

LA CASA DE LAS FUENTES

MIAMI BEACH, USA
Pages 98–111

PASEO DE LOS LAGOS

MADRID, SPAIN
Pages 112–119

GREENWICH VILLAGE APARTMENT

NEW YORK CITY, USA
Pages 122–133

POLYCHROME HOUSE

SYDNEY, AUSTRALIA
Pages 134–139

PARIS ÉTOILE

PARIS, FRANCE
Pages 142–153

OSBORNE BUILDING RESIDENCE

NEW YORK CITY, USA
Pages 154–157

CASA OLABUENAGA

MAUI, USA
Pages 158–163

YORK WAY

LONDON, UNITED KINGDOM
Pages 164–167

PROFILE
NINA YASHAR

ITALY
Pages 168–179

PARISIAN APARTMENT

PARIS, FRANCE
Pages 180–189

PARK AVENUE APARTMENT

NEW YORK CITY, USA
Pages 190–197

ITALIAN PAD

SAN VITO DI LEGUZZANO, ITALY
Pages 198–203

PROFILE
DIMORE STUDIO

ITALY
Pages 204–215

VILLA BORSANI

MILAN, ITALY
Pages 216–229

PIETRO'S HOUSE WORKSHOP

MILAN, ITALY
Pages 232–237

MAGICAL MONSTER MIX

JUTLAND, DENMARK
Pages 238–243

MILAN TODAY APARTMENT

MILAN, ITALY
Pages 244–253

INDEX

Pages 254–255

A FEAST FOR THE EYES

Doyenne of American fashion Diana Vreeland nailed the notion of glamor when she coined the word "pizzazz." Meaning flamboyance, and the delight of the new, even when she did simple, she did it to excess. Vreeland had an eye for color, pattern, and achingly high style. As demonstrated in her all red Park Avenue living room decorated in the 1950s by interior designer Billy Baldwin, she wasn't one to conform. Using a Persian-inspired scarlet floral chintz from Colefax&Fowler to envelop the entire space, the scheme was to suggest a garden—but a garden in hell. Baldwin observed that the apartment was "the most definitive personal statement" that he had ever seen in all his years of decorating. Vreeland knew that being brave makes you stand out from the crowd. Fearless, charismatic, and far from boring, welcome to the House of Glam.

"A GLAMOROUS INTERIOR REFERENCES THE PAST, WHEN PEOPLE WERE GREAT AT LIVING BIG."

Imagine sipping cocktails within bombshell architecture such as the John Lautner-designed "spaceship" house as the sun goes down over the Hollywood Hills. Or lounging in white silk pajamas looking up at the mirrored ceiling of a 1930s bedroom designed by American society decorator George Stacey. Or partying within a stacked, overtly decorated townhouse exploding with joie de vivre. Here, traditional techniques such as *verre églomisé* and silk-embroidered walls are paired with sculptural furniture, brass accents, and bespoke handwoven rugs. This diverse architectural landscape is a feast for the eyes, where expressive colors, textures, unusual forms, and exotic materials combine to create a contemporary interpretation of an art deco or classic 1950s Hollywood film set interior. It's fun. After all, designers are innate history buffs and there is a wealth of history in architecture, decorative arts, fashion, and film through the ages to cherry pick and play with. These homes dream big.

"A glamorous interior is rich with color, material, and texture, and more often than not, it references the past, when people were great at living big," explains Paris-based property developer and designer Ashley Maddox of Studio Maddox. She firmly believes that glamorous interiors are layered over time and often feature traditional elements such as hand-painted wallpaper, blown-glass chandeliers, marble chimneys, velvet, brass, thick carpets, and the like. But more than that, decoration is an extension of a personality. Think of a glamorous interior and the homeowner, too, is often next level. In the glimmer of the elite hanging out in a nineteenth-century French or Italian salon, glamor is not only to do with lavish good looks but also a building's recreational purpose. These interiors were designed not solely for aristocratic taste but equally for the visiting guest. Like the most exclusive member's clubs today, every well-dressed living room is a fizzing mix of personality, lifestyle, and fierce design. ▶

PREFACE

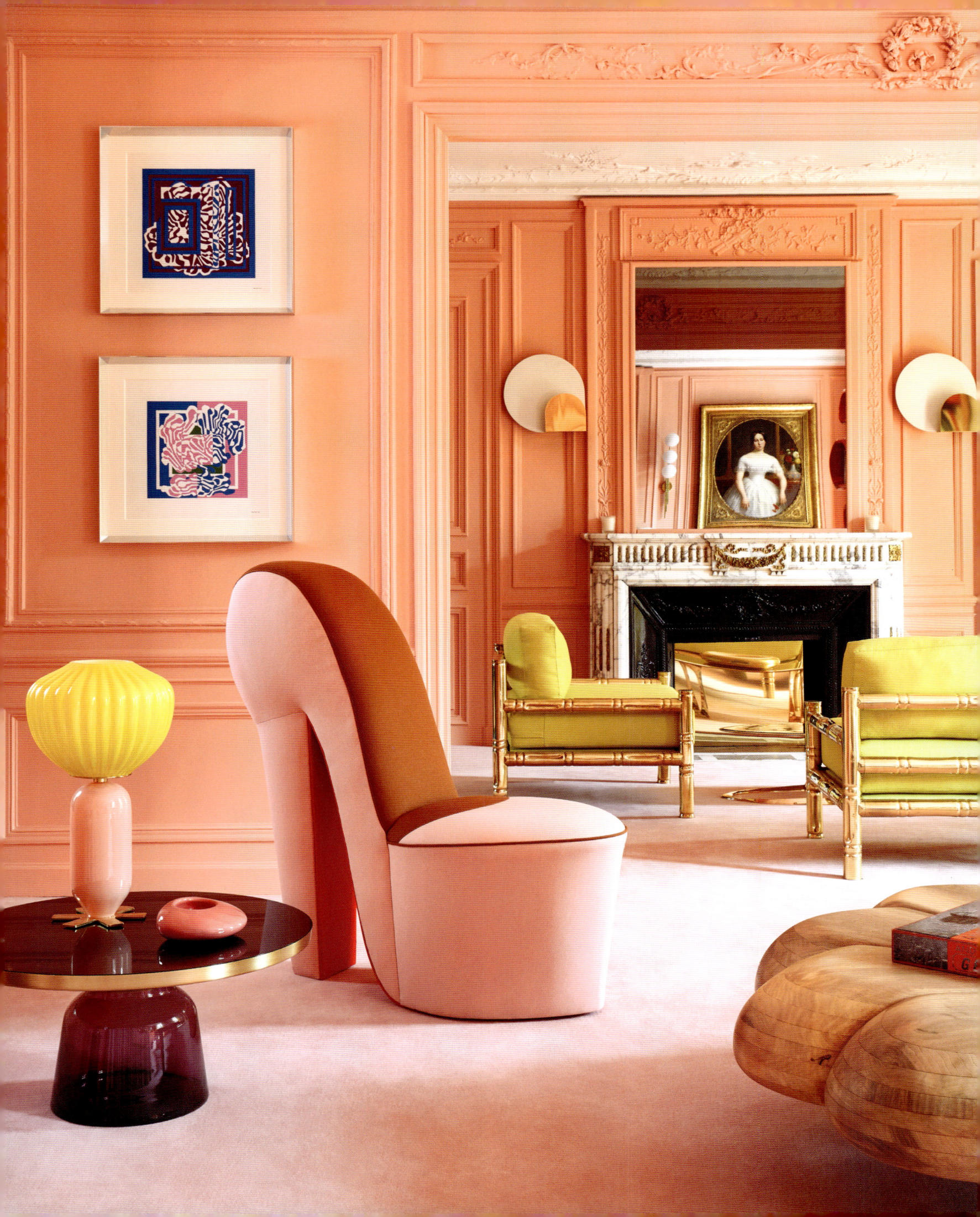

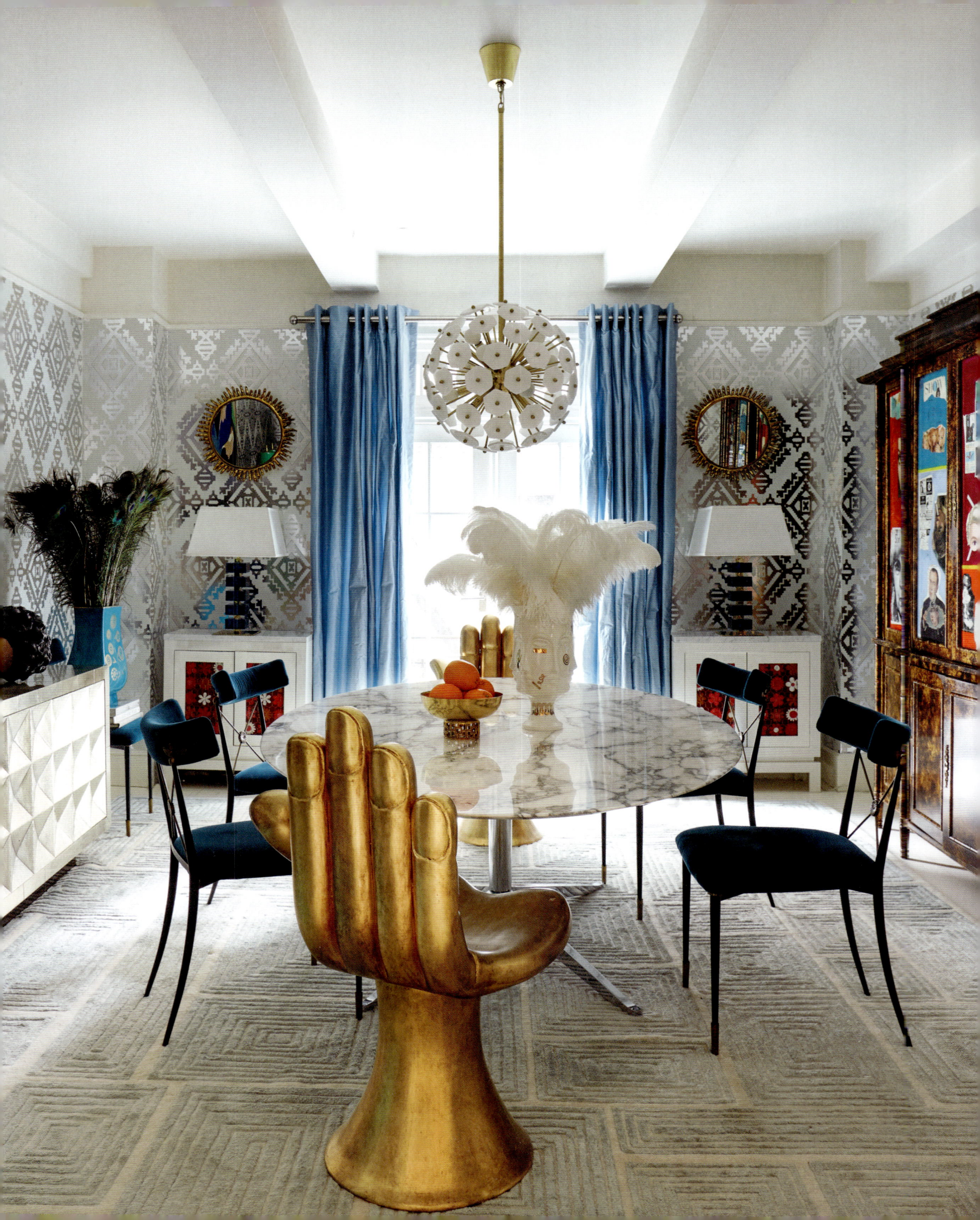

▶ This is a sentiment shared by LA-based interior designer Caroline Legrand, who is known for her inviting and show-stopping schemes. "I am obsessed with John Lautner's buildings," she enthuses. "The fact that these houses are still so relevant today and the materials used have survived up to five decades is truly admirable." Her favorite Lautner masterpiece is the Sheats-Goldstein house in Beverly Crest, LA—adored for all it's made-to-measure furniture that's been preserved fabulously by the owner since 1963. It's the experimental shapes, proportions, and angles all set against the wild Californian landscape that make these modernist buildings in California an architect's dream. What makes them relevant today is the use of materials: abundant glass, concrete, wood, and stone. Built by hand, bespoke, and triple-height, with a medley of marble or veneered chevron floors, when it comes to pattern and patina these materials never get old.

MODERN-DAY DESIGNERS CREATE INTERIORS WITH A COOL EDGE THAT STRIKE A POSE.

Today, we're reinterpreting these same elements but with a contemporary sophistication and polish. Modern-day designers are adept at weaving together historic styles, from art nouveau and art deco to elegant mid-century and the postmodernism of the 1970s and 1980s, but with a cool, modern edge. They create interiors that strike a pose. In the words of fictional intelligence agent Eve Polastri in BBC America's *Killing Eve,* the Parisian apartment of assassin Villanelle is "chic as shit"—and like Villanelle's multilayered character, the style is broader than you think.

On one side, it's the camp theme of the 2019 gala at New York's Metropolitan Museum of Art; on the other, it's Carolyn Bessette-Kennedy in the 1990s wearing a black Calvin Klein gown. In fashion, it's contemporary British designer Molly Goddard serving up visions of color and frills; in modern interiors, it's the grand salons and bold mixes by hip Milan-based Dimore Studio. Here, pieces by Carlo Scarpa and Gio Ponti are juxtaposed with sumptuous gold fringing and bespoke leather-and-brass chandeliers. Whatever the context, the look is retro and fresh at the same time.

"We create spaces that have a sense of history, without being recreations of history," say Dimore Studio founders Britt Moran and Emiliano Salci. "We like to give a design roots that people can identify with, whilst making the space contemporary and up-to-date through the use of colors and materials that reflect today. Our aesthetic is current, contemporary. It's a mix of different eras, styles, and ideas. The arts, fashion, even food—all these concepts come together. Our design process starts from a thought and mood to which we have been drawn—it can be an opera, a movie, a fashion show, or an exhibition—that we develop and make ours by adding new things to it and new ideas. The initial concept could be the sanatorium by Alvar Aalto, for example, or the pantry of the Villa Necchi Campiglio in Milan. It's like having a magnet to which different ideas are drawn to create the final project." Like Surrealist artists, their work looks back to a range of influences, which they interpret in their own unique way.

Classical traditions of art and architecture as well as innovative, decorative values have always been a cornerstone of Italian design. When asked to define the elements that make up the House of Glam mood, curator Nina Yashar of Nilufar Gallery in Milan suggests combining furniture from historic Italian design (twentieth century) with handmade, one-of-a-kind designs. Art and textiles are equally important for the sophisticated narrative: her dream interiors would be stitched together with paintings by Francis Picabia, contemporary rugs by Martino Gamper, and fabrics made by Tessitura Luigi Bevilacqua in Venice. For Yashar, these apartments contrast ancient frescoes with gleaming contemporary design. It is haute couture reimagined for the home.

Creatives from further afield are also taking the "haute home" route, not influenced or restrained by preconceived notions of Western interior design. The artistic expertise of Moscow designer Ksenia Breivo layers color and pattern to breathtaking effect. ▶

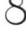

▶ Her experimental and timeless interiors pack a visual punch with their cool, edgy designs that utilize artisanal techniques. Creating one-off objects in shapely forms that echo a legacy of 1940s France, in her hands, interiors take on a glow.

Casa Perfect by name, Casa Perfect by nature, the recent project by curator David Alhadeff of influential design gallery The Future Perfect delivers contemporary design credentials to a West Village brownstone in New York City. Elevating retail to new heights, the project showcases contemporary design talent within nineteenth-century surrounds. "I am looking for work that is well crafted, well considered, proportioned, and carries the signature style of the designer who created it," says Alhadeff on the criteria he looks for in a standout piece of furniture. "Although The Future Perfect is a contemporary design gallery, I do also like historical work. Ultimately, I am looking for work that carries the hand of the maker. Whether that's Gabriella Crespi or Chris Wolston, that's a thread that runs through my critical selection."

It could be the artist's use of bold colors or figurative technique, or simply the use of beautiful materials that draws Alhadeff's eye. "In the end, in all instances it's in the details," ▶

PREFACE

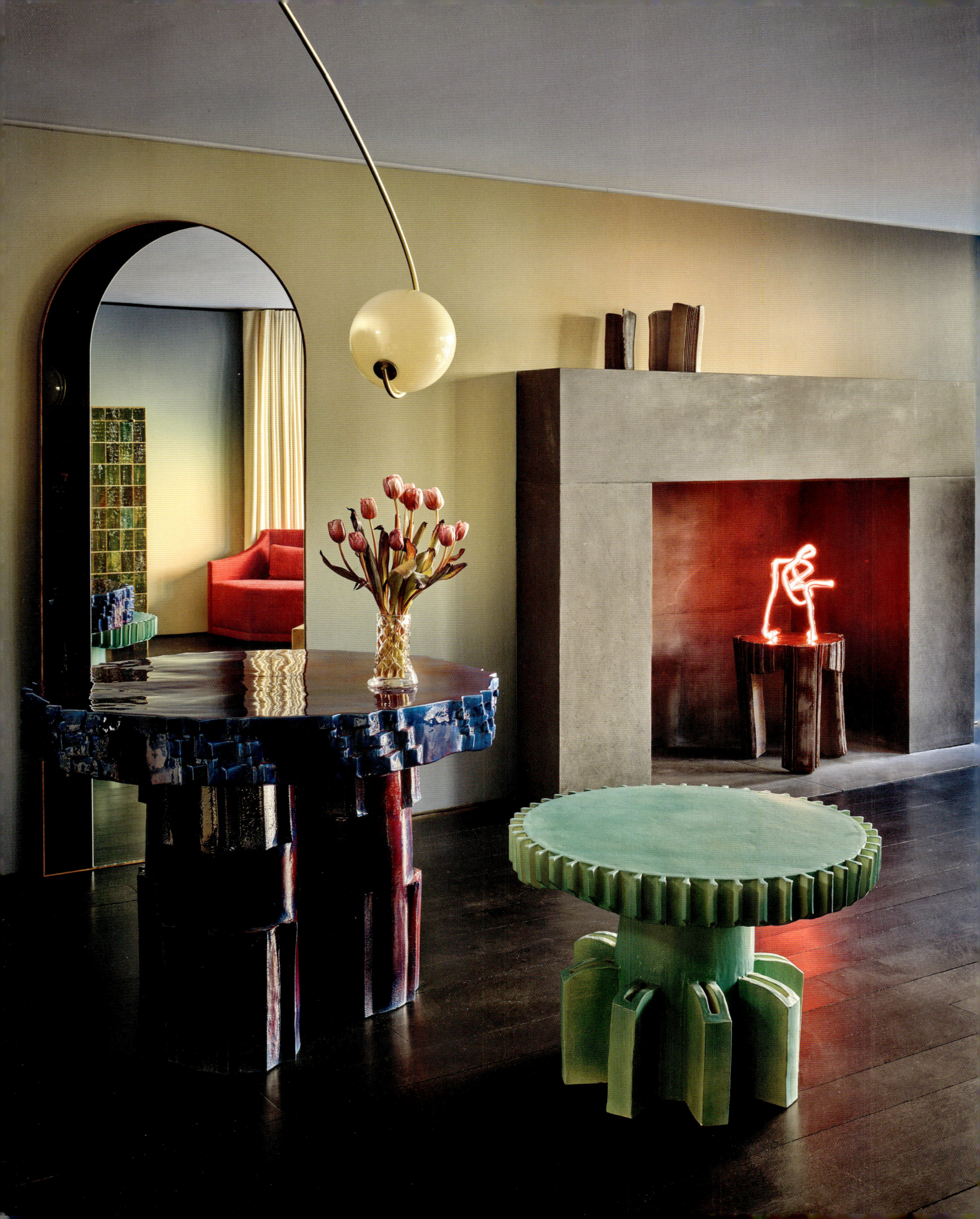

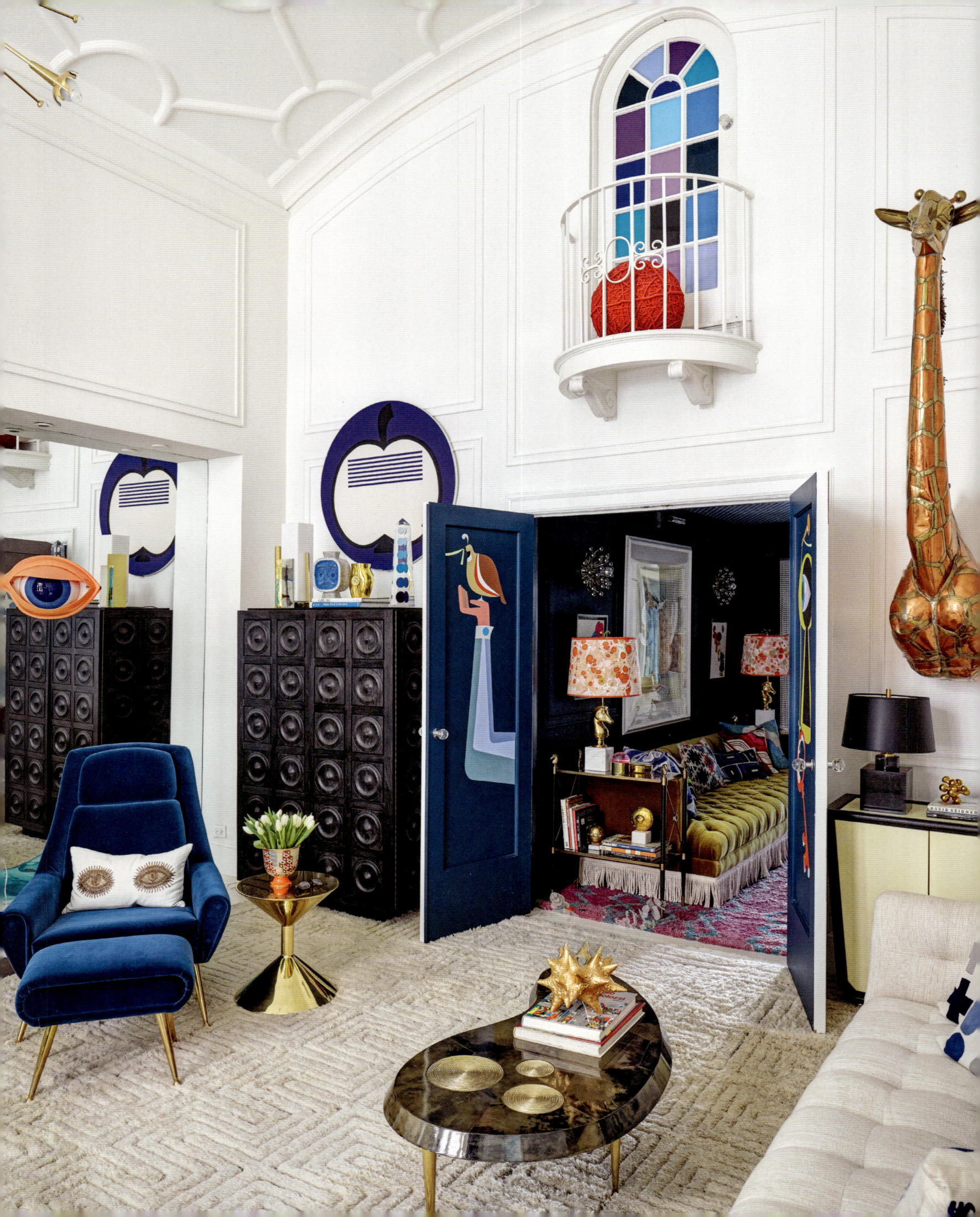

he explains. "If the details are well considered, the experience is heightened. I think that is one of the crucial differences of work that's okay and work that's great. Did the designer/maker/artist laboriously consider the details or did they cut a corner? It makes a huge difference for me." On the question of what has marked a cultural shift toward a style that is more sophisticated and glamorous, Alhadeff says: "I think the pendulum swings one way and it swings back the other. Right now, there is certainly a lot of room for eclecticism and for people to express their individual taste through their art and objects. But it could easily be in the coming years that we return to a fondness for the spare minimalism of the mid-century."

Maybe the draw is a small act of rebellion against the simplicity of Scandinavian-inspired minimalism and mid-century good taste. Perhaps it's in reaction to an uncertain socio-economic and political climate that we have begun to crave whimsical patterns and tactile designs that feel reassuring, and an intense, saturated palette. Or maybe the aesthetic is born as a response to mass production and an increased design savvy, where the culture of Ikea-style identikit homes has left us wanting to express ourselves more individually, so we seek out artisanal pieces handmade by skilled craftspeople.

EVERY ROOM TELLS A STORY. HOW YOU CHOOSE TO DECORATE IT IS PART OF THE PICTURE.

"I think we need to be really careful when we talk about what has been and will be, that we don't reduce time into a history of neat categorizations and understand that at any one point there has always been and will always be different styles and aesthetics at play," interior designer Martin Brudnizki adds to the fray. "You hear a lot about trends in maximalism as a reaction to the minimalism of the 1990s. But as Foucault says, we need to 'question those ready-made syntheses.' In the 1990s you still had designers like Mario Buatta creating beautiful work. However, if there has been one objective that has remained constant over the last century, it is a desire for glamor. When you look throughout the twentieth century, you see during every evolution of the modern movement that society had a counterpoint."

Brudnizki notes that during the 1930s, when much of art deco became mainstream, you had the likes of John Fowler or Elsie de Wolfe creating very colorful interiors. During the mid-century, you had designers like Sister Parish or Madeleine Castaigne. During the 1980s, it was Renzo Mongiardino—to name but a handful of many talented designers. Nowadays, many people have their own idea of what glamor is and it can be found equally in a gleaming, streamlined experience and in an opulent interior composed of many layers. For Brudnizki, it's not about modern versus classical, but about the romantic and creating your own elegant world.

Every room tells a story. How you choose to decorate it is part of the picture. How you use the space completes it. What connects the dots of these uber interiors is that they play host to a virtual party, dizzying in their unapologetic exuberance, daring, sophistication, and modernity. Anything but basic in their architecture, landscape, interior application, select choice of furniture, art, or the drama of the person, these homes push design boundaries in their desire for transformation.

For instance, why not have a pool inside your Parisian 1970s bachelor pad? Or instead float around in a black tadelakt pool carved into the Andalusian hills? Choose curved furniture with chrome details and arrange it to relish cinematic views. Commission ceiling art with frescoes applied directly to oversized concrete panels—every inch of which is hand smoothed. Whether it's a rekindling of the Versailles kind or a 1960s-meets-futuristic design medley, assured taste and passionate autocracy sets these homes apart. Imagination is the chief factor, plus the evident delight of the people that put them together. What unites these homes is their sense of escape. ◆

CRISTINA

Storytelling, historical icons,
and contemporary
originality ensure that designer
Cristina Celestino continues
Milan's reputation as a city
of excellence.

CELESTINO

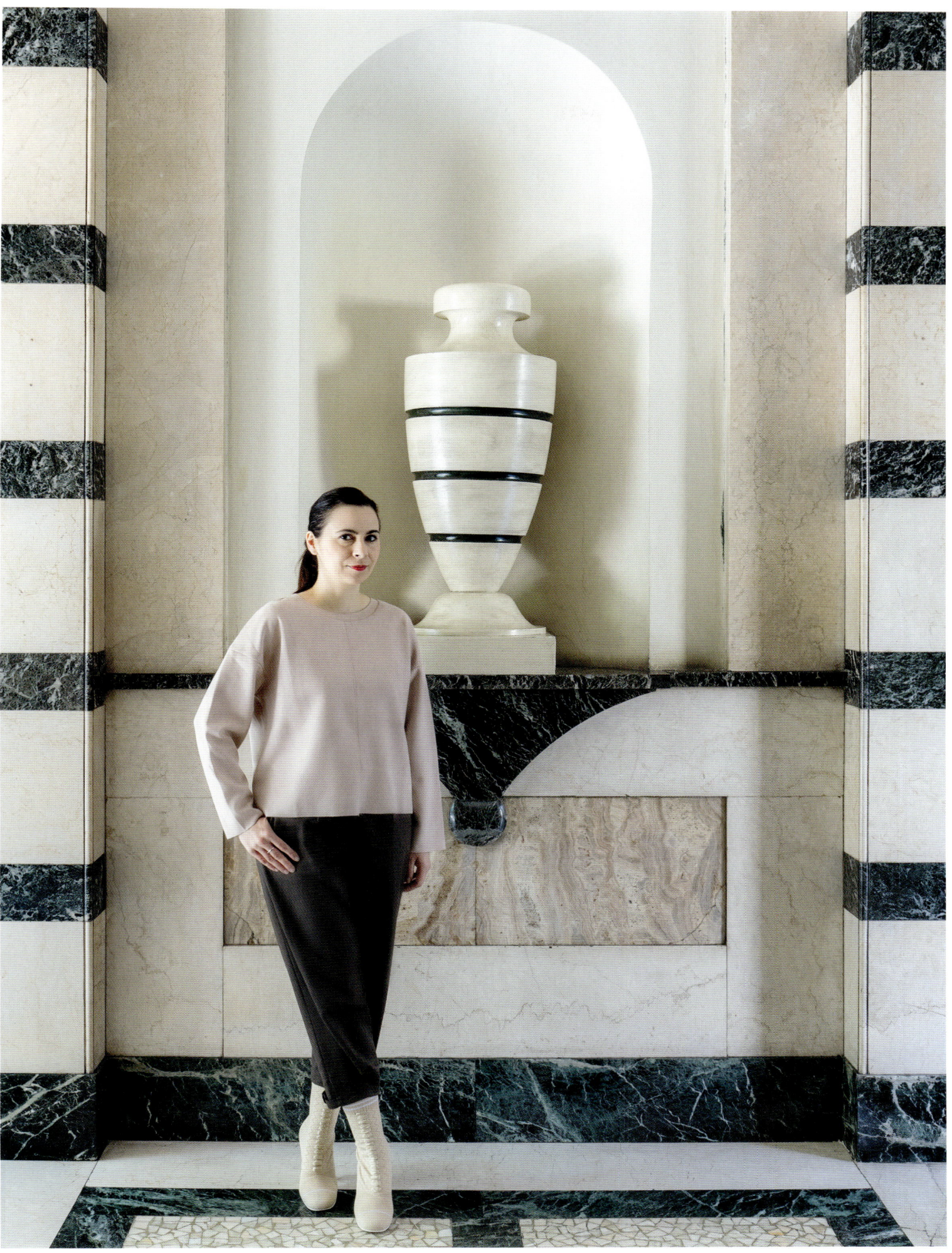

13

CRISTINA CELESTINO

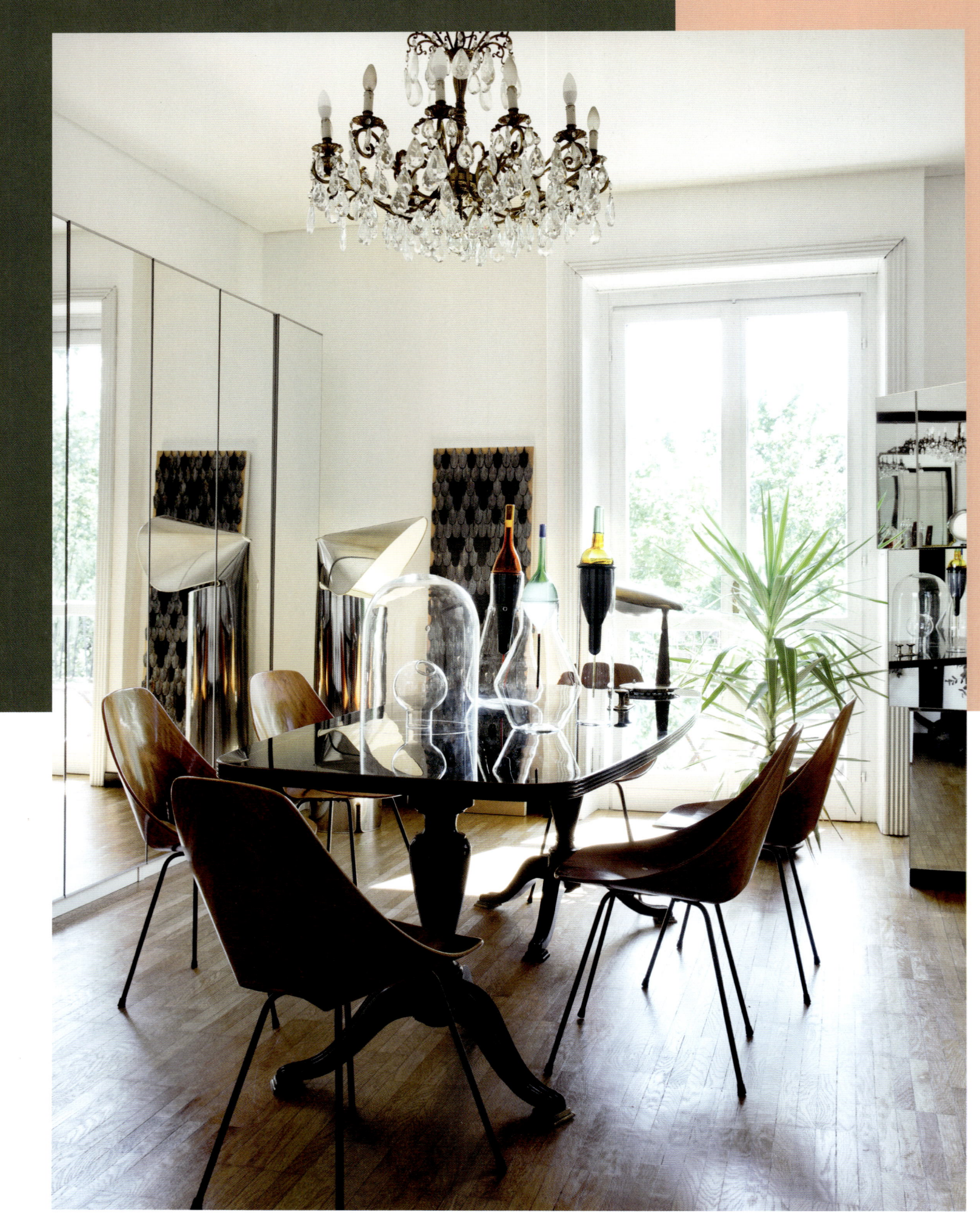

The dining room of Celestino's home has an iconic lamp by Mario Bellini, wooden chairs from the 1950s and a wall-mounted case with prototypes from her Atomizer collection (*above*).

Italian design is part of Cristina Celestino's DNA. Not only is she one of Milan's foremost designers, having created her own furniture brand called Attico Design and leading the creative direction of interiors and displays for companies like Fendi, she too is passionate about Italy's historical greats, from Carlo Scarpa and Ettore Sottsass to Gino Sarfatti and Luigi Caccia Dominioni. She is also a collector who believes that the past is inexorably linked to the future. Referencing designer and architect Nanda Vigo, Celestino proclaims: "Future exists in the past and both are part of all," or in other words, all time is entwined.

Celestino mixes a contemporary approach with traditional style and materials by way of giving shape to new objects and concepts. Her biggest projects have included working with Fornace Brioni as creative director, an association that started in 2016, and collaborating with Fendi to create The Happy Room during Design Miami 2016, not to mention her traveling salon, Tram Corallo, a 1928 tram that she transformed into a time capsule of old-world glamor. She believes that "the key [to her success] is to understand for every project the client's needs and heritage, and the material features, connecting them to my design vision and aesthetic with respect and mutual trust." Celestino plays with texture, shape, color, and the materiality of different finishes, and also focuses on functionality while keeping the evocation of narrative at the forefront of her approach.

Take, for example, her Pulsar light, a suspension lamp comprised of brushed-brass rings within which multiple lights rest within hollow crystals, or her Ecstasy dressing table—part of her Attico Design label—made of solid oak and copper, with several round mirrors within which to gaze. The Nebula collection for Besana Carpet Lab uses different tendril flower shapes, from bright red poppies to a softer palette of pale blues and purples, and her collection Scenografica for Fornace Brioni is inspired by the Italian baroque—artifice and art informing her glazed ceramics and trompe l'oeil visions of curtains and interior domes.

Attending the School of Architecture at Università IUAV di Venezia, Celestino studied design by avidly reading books, monographs, and auction catalogues, after which she began collecting rare design books such as the catalogue for Museum of Modern Art's landmark "Italy: The New Domestic Landscape" exhibition, as well as profiles on her favorite designers and architects. After graduating and moving to Milan in 2009, she worked with prestigious design studios focusing on interior architecture, after which she decided to take the leap and design furniture on her own. Given her dual love of both design and architecture, it is not surprising that Celestino cites Le Corbusier and Carlo Scarpa among her role models: "In both cases, their respective architectures contain 'design products' in the form of micro-architecture, from a door handle to a rainwater drain or a bench." For her, each was unique for their contemporary vision, which still has influence today.

While Milan is not her hometown—Celestino was born in Pordenone, a province north of Venice, in 1980—it is where she has based her studio since 2014. She underlines, "I can hardly think of another Italian city as good as Milan [in which] to live and grow your own design-architectural business." A stimulating city filled with craftspeople, local suppliers, brand showrooms, and companies, Milan too is filled with inspiring historical buildings like the Palazzo Reale, as well as modernist masterpieces such as Angelo Mangiarotti's church in the district of Baranzate. However it's not only the city's grand architecture that appeals to Celestino, who says, "I also love to discover Milan's anonymous beauty—interiors, like entrance hallways," continuing, "they connect private and public areas and usually show unexpected materials mixed with unique decorative and architectural solutions."

Why does Celestino think Italian design has become so recognized and appreciated around the world? In contemplating this question, she refers to the recent past, describing how "in the postwar period many illuminated entrepreneurs turned to figures such as architects and designers." She believes that these friendships ▶

"THE KEY TO SUCCESS IS TO UNDERSTAND FOR EVERY PROJECT THE CLIENT'S NEEDS AND HERITAGE, CONNECTING THEM TO MY DESIGN VISION AND AESTHETIC WITH RESPECT AND MUTUAL TRUST."

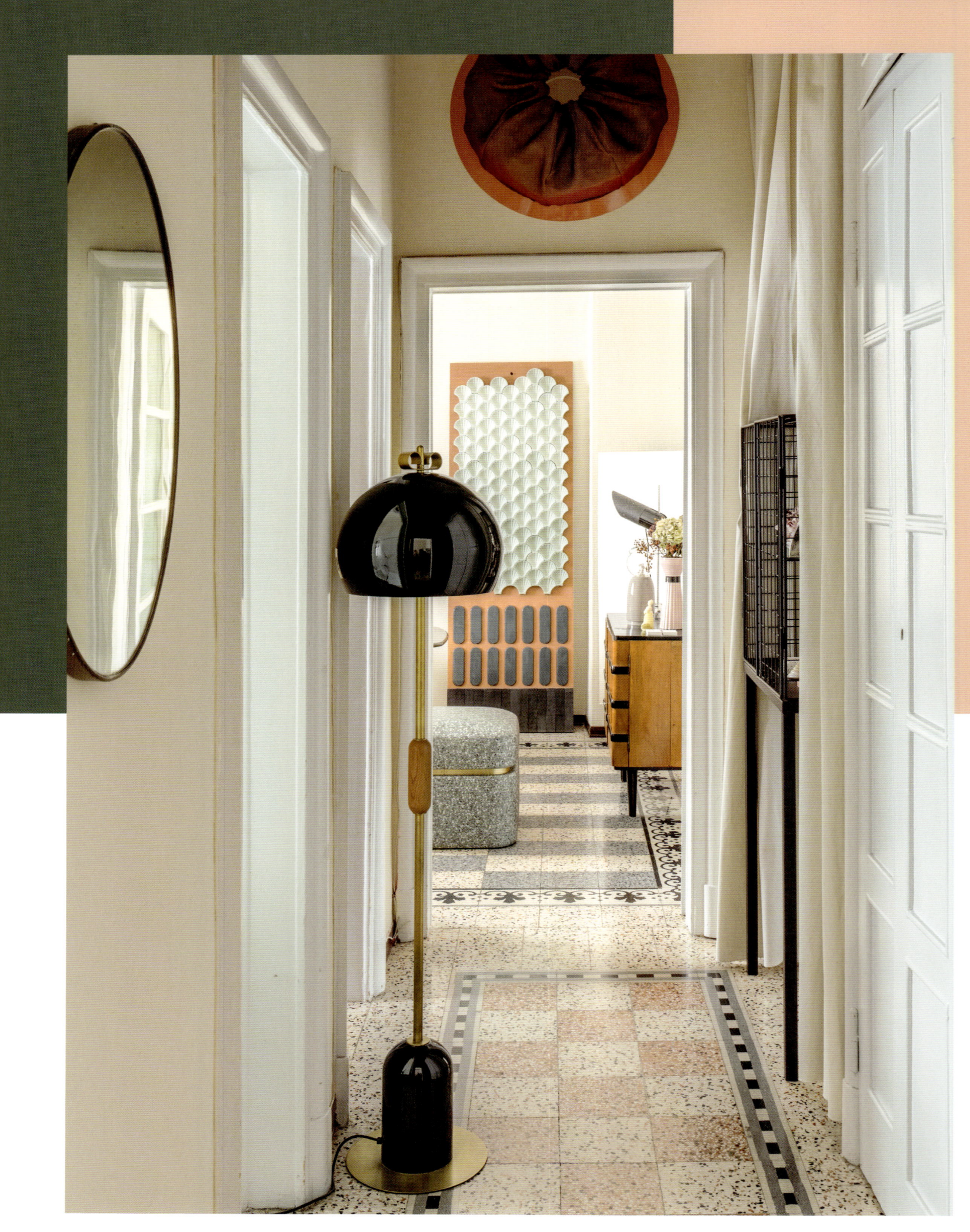

CRISTINA CELESTINO

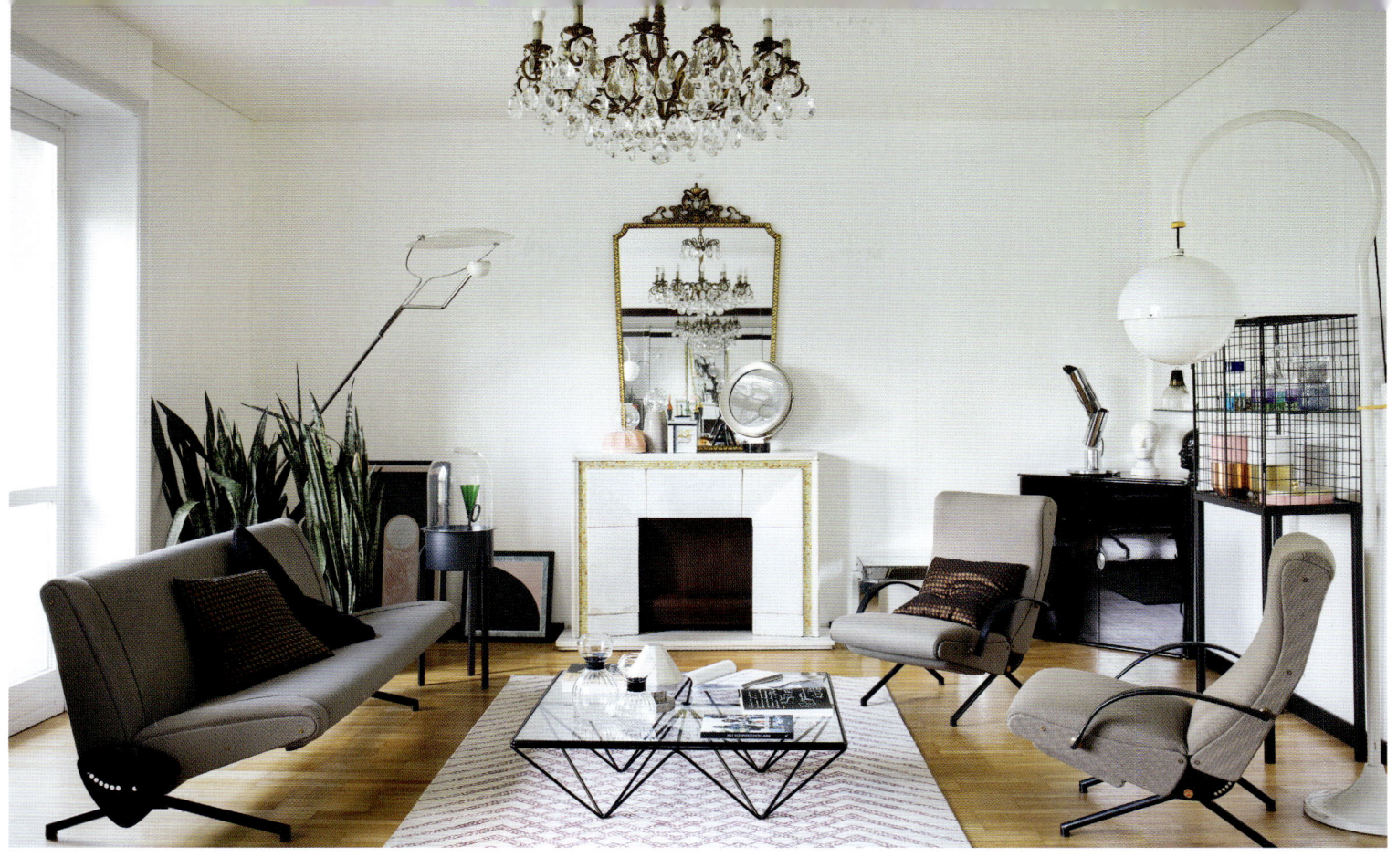

The dramatic circular shapes of this black floor lamp lend the hallway theatricality, while in the studio room ahead rests a Rocaille wall covering, part of the collection Garden of Delights, designed for Fornace Brioni (*left*).

Celestino's apartment combines wooden flooring, marble and original doors. Sliding doors divide the grand sitting room and dining room, the latter features Borsani's sofa and armchairs by Joe Colombo along with a floor lamp by Kartell (*above*).

CELESTINO CONTINUES MILAN'S REPUTATION AS A CENTER OF EXCELLENCE.

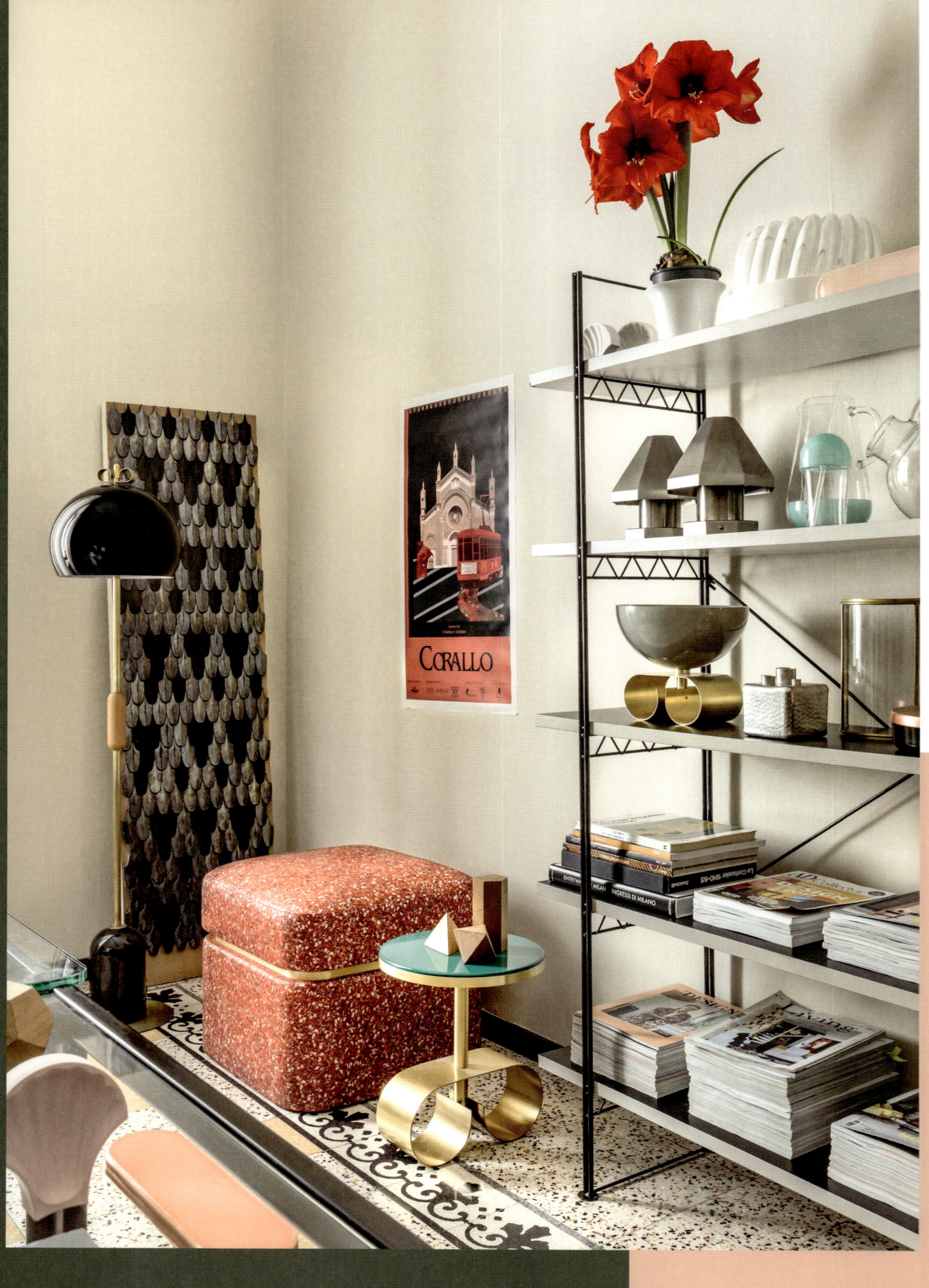

From the brushed metal side tables to the shelves stacked with design magazines, glass jugs and other ornaments, Celestino's studio is jampacked with decadent and luscious materials (*left*).

Different material textures combine to bring a dynamic energy to this sitting space, from the leather hides lining the chairs to the purple patterned carpet upon which they sit (*above*).

CRISTINA CELESTINO

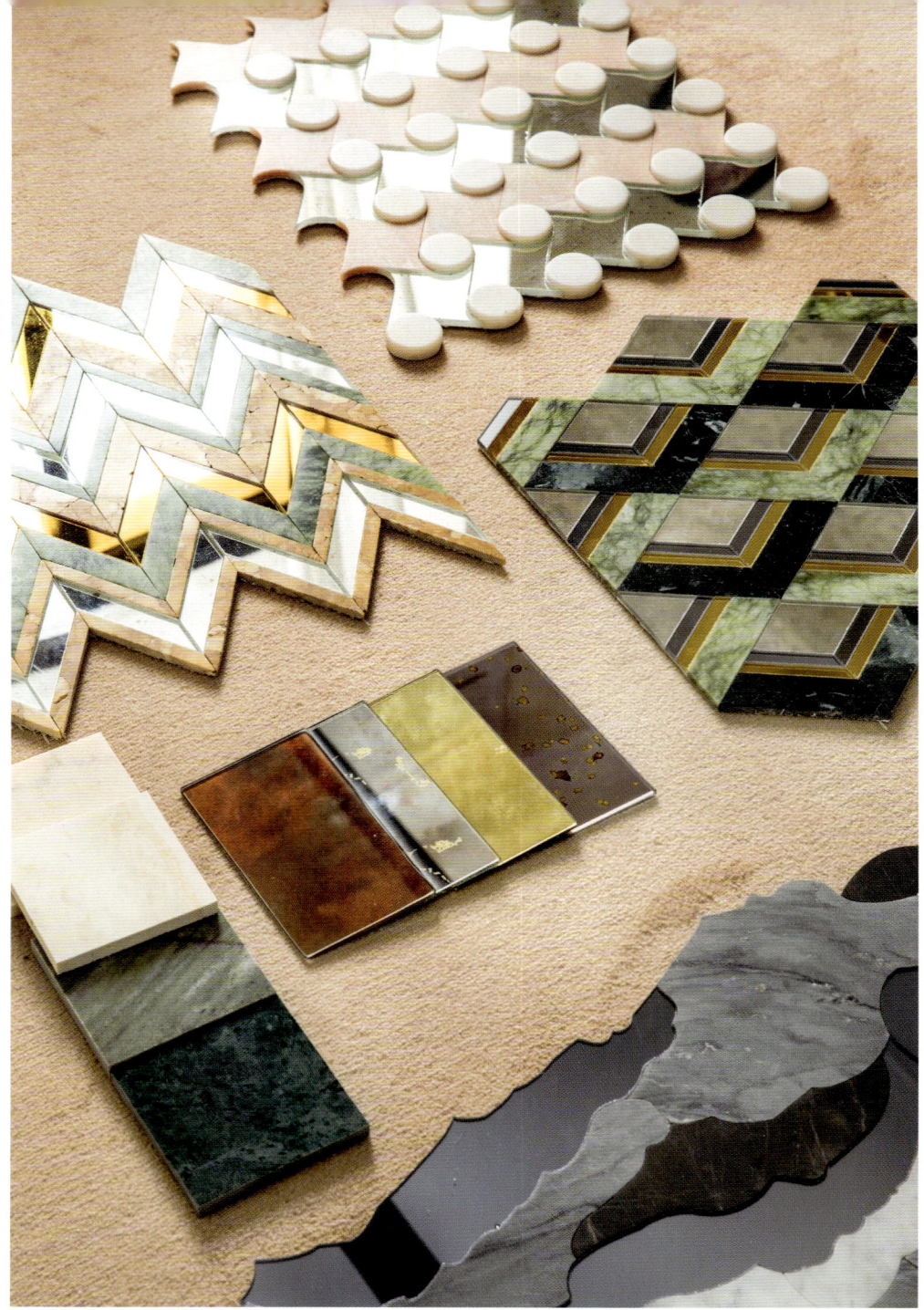

▶ "brought to light not only products that were innovative for that time and are still iconic today, but a completely new vision and concept of living. This was made possible also thanks to the presence in Italy of excellent manufacturers and artisans in its diverse districts."

Fashion and art are an important source of inspiration for Celestino's designs. It is the functional aspect of fashion that she sees as being connected to design; meanwhile, art occupies a space of the future imaginary, one that is ideally independent of commercial interests, and in this sense can be a "limitless source of inspiration." Her designs have an openness and cross-disciplinary approach that harnesses something akin to the functional imaginary, with color combinations and graphic motifs that reach for both aesthetic and conceptual originality, as well as practical needs.

Having developed successful collaborations with so many brands, one of Celestino's talents is being able to translate her DNA as a designer into such a wide range of projects, taking into account different needs, personalities, and creative solutions. As she highlights when describing the key to her method: "When I design an interior or a piece of furniture, my design approach is almost unchanged; I try always to express my vision starting from a process of extensive research in different fields. When I think of a product, I always begin from a story and from the space where the object will be placed." It is this combination of narrative, historical precedents, and contemporary inventiveness that she fuses to make her designs stand out. And with such a rich history to draw upon, Celestino continues Milan's reputation as a center of excellence, bringing her innovative energy to continue the story. ◆

Pattern, texture, colour and mood are combined in this selection of tiles, from zigzags to polka dots (*above*).

Celestino's studio showcases pieces including terracotta surfaces by Fornace Brioni, a bubble-gum pink Bon Ton Table Lamp for Torremato and the Orfeo mirror for her own brand Attico Design's Corolla collection (*right*).

In the entrance hall of Celestino's home, her new Sipario collection is on display, the onyx shelf embellished with trimming below that nods to the 1940s (*page 22*).

CRISTINA CELESTINO

CRISTINA CELESTINO

"I TRY ALWAYS TO EXPRESS MY VISION STARTING FROM A PROCESS OF EXTENSIVE RESEARCH IN DIFFERENT FIELDS."

—

◆ ◆ ◆

ESTER'S APARTMENT 2.0
BERLIN, GERMANY
DESIGNER ESTER BRUZKUS ARCHITEKTEN
RESIDENT ESTER BRUZKUS

BOXES WITHIN BOXES

Step into Ester Bruzkus's top-floor apartment in the Prenzlauer Berg district of Berlin and you will see a huge single space, harmonious in tone and clutter free, with glazing at either end that gives way to decking and views of the city beyond. Inside, the living room, kitchen, and dining room share a bright and airy volume sandwiched between a polished concrete floor and a raw concrete ceiling. A wall paneled in blond oak flanks the kitchen on one side of the room, while opposite the sofa in the living area is a wall of gray-painted wooden slats. These novel surfaces have great visual impact but also serve to conceal hidden volumes beyond—what Bruzkus refers to as "boxes inside boxes." Behind the blond oak lies a bathroom and, beyond that, a bedroom, while the painted wooden slats open up to reveal generous wardrobe space.

Within the vast living space, Bruzkus has used color to define specific areas. The back wall, for example, though one single volume, is painted half mint green, half chalky white to mark the boundary where the dining and living areas meet. Given the openness of the space here, Bruzkus has taken great care over a limited yet sophisticated color palette: that minty hue on the wall repeats in the green of the dining table; the lush cranberry of the sofa is complemented by the rose pink of the kitchen. Bruzkus's meticulous planning of space, and specifically her use of color and light within it, are fundamental to the success of the scheme. ◆

Bruzkus has filled her apartment with furniture designed by her (the Memphis Melon dining table and plush pink sofa and pouf) or in collaboration with former business partner Patrick Batek (the marble-topped tables). (*above, opposite, and overleaf*)

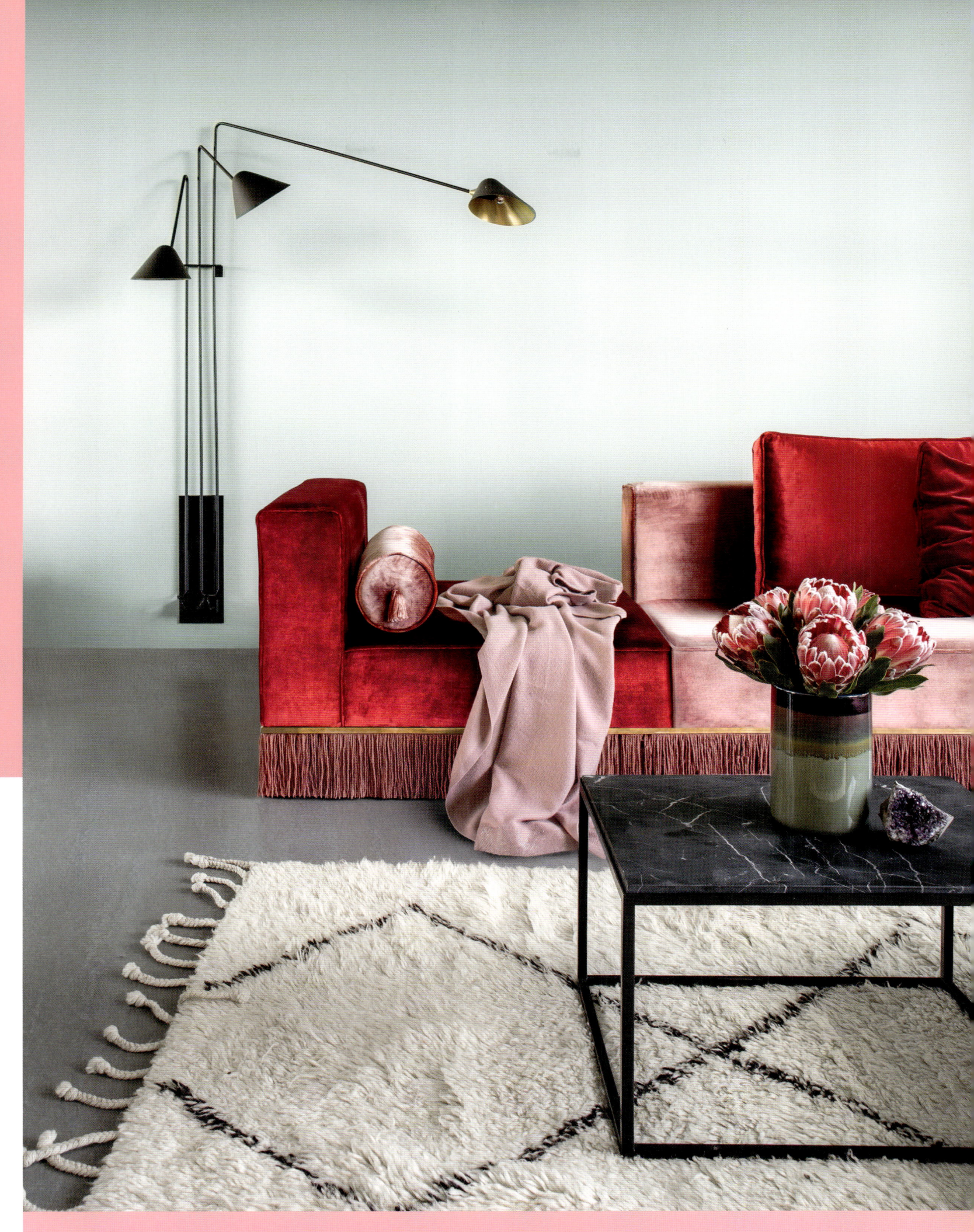

Esther Bruzkus stands on the decking that surrounds her apartment, with the Berlin skyline behind her (*right*). Both the kitchen and the bathroom are kitted out with terrazzo and the color palette is from the Les Couleurs Le Corbusier range.

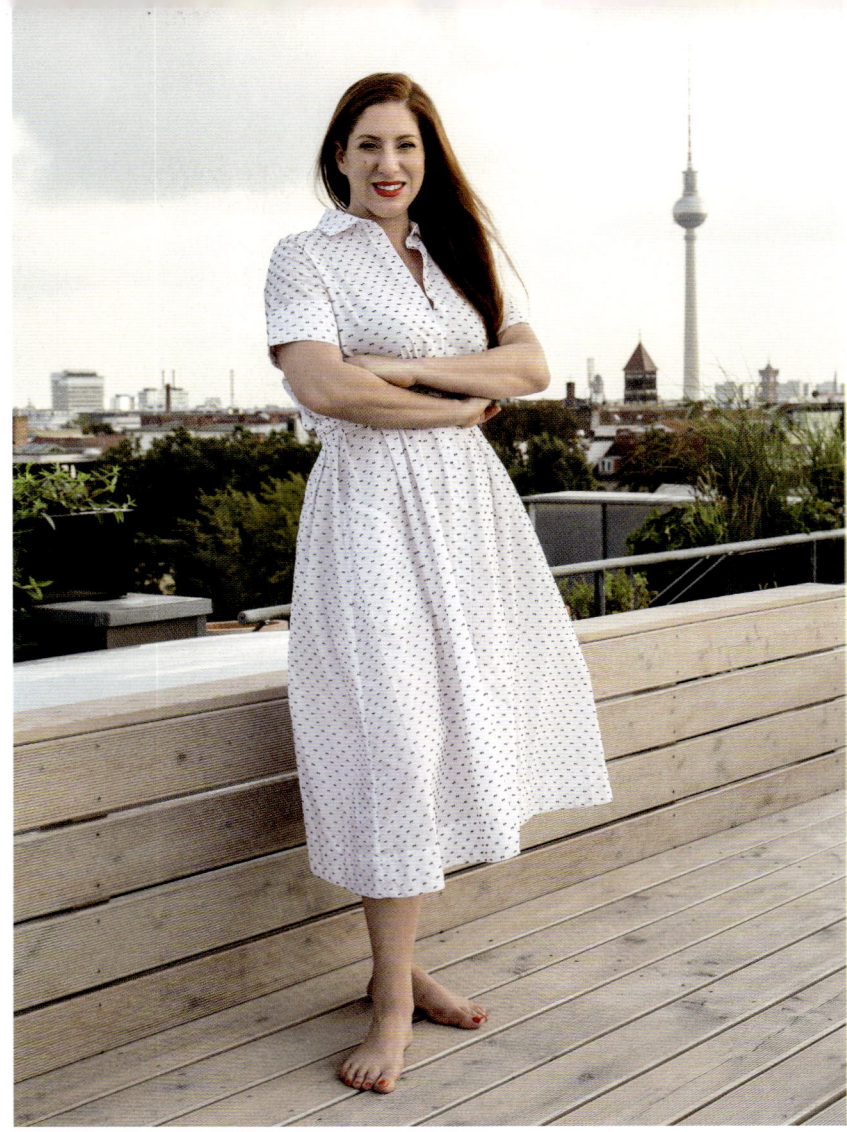

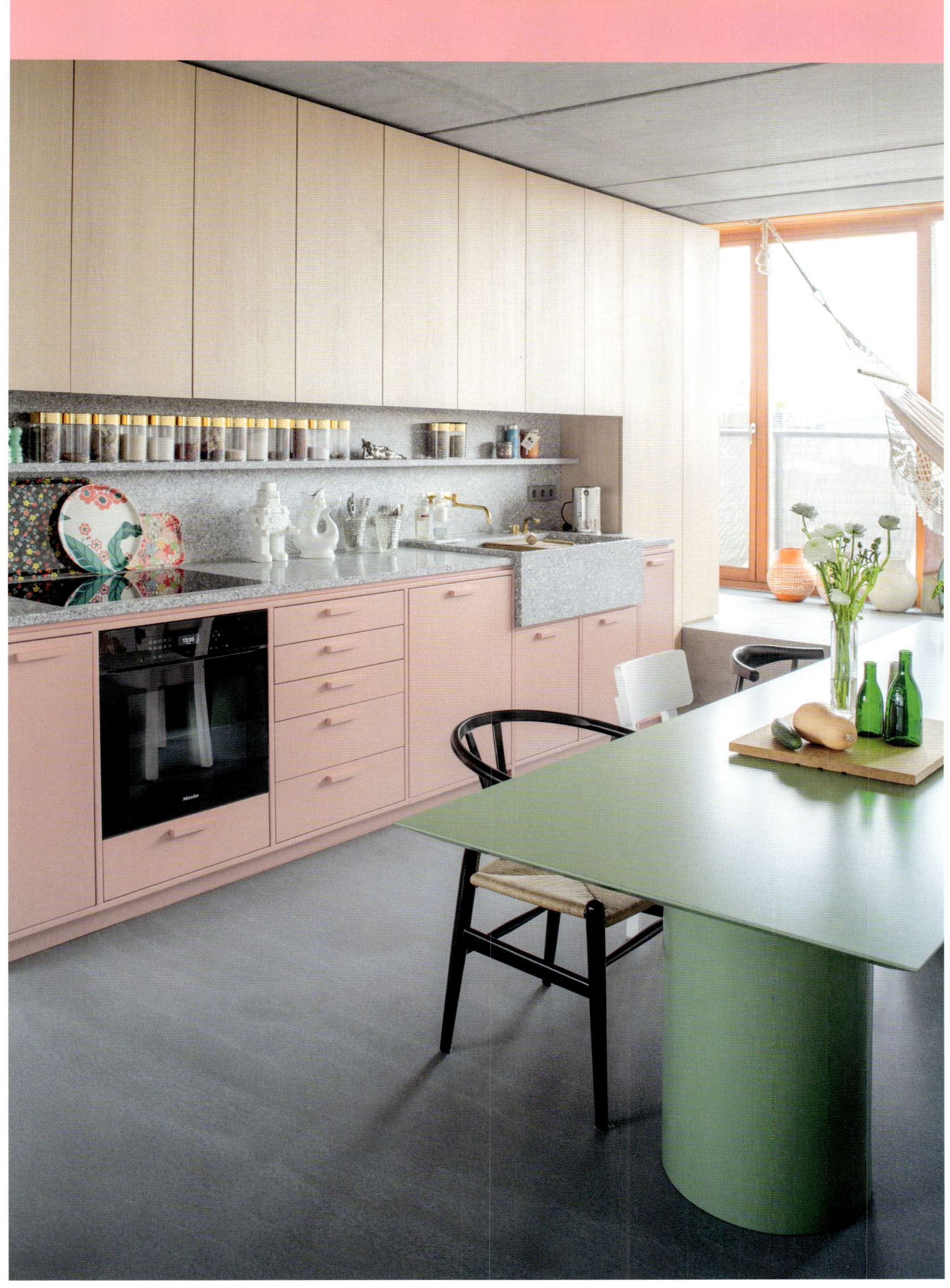

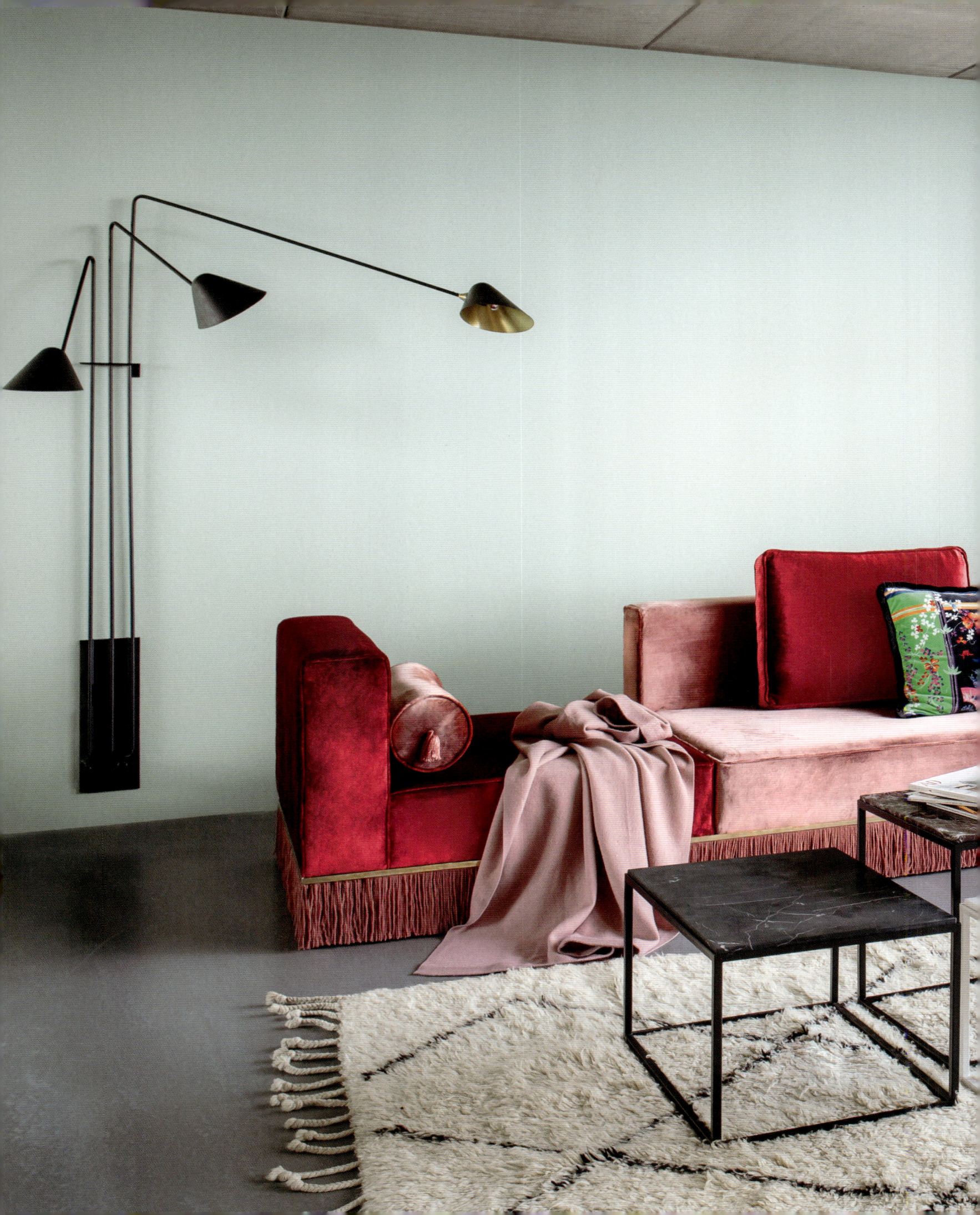

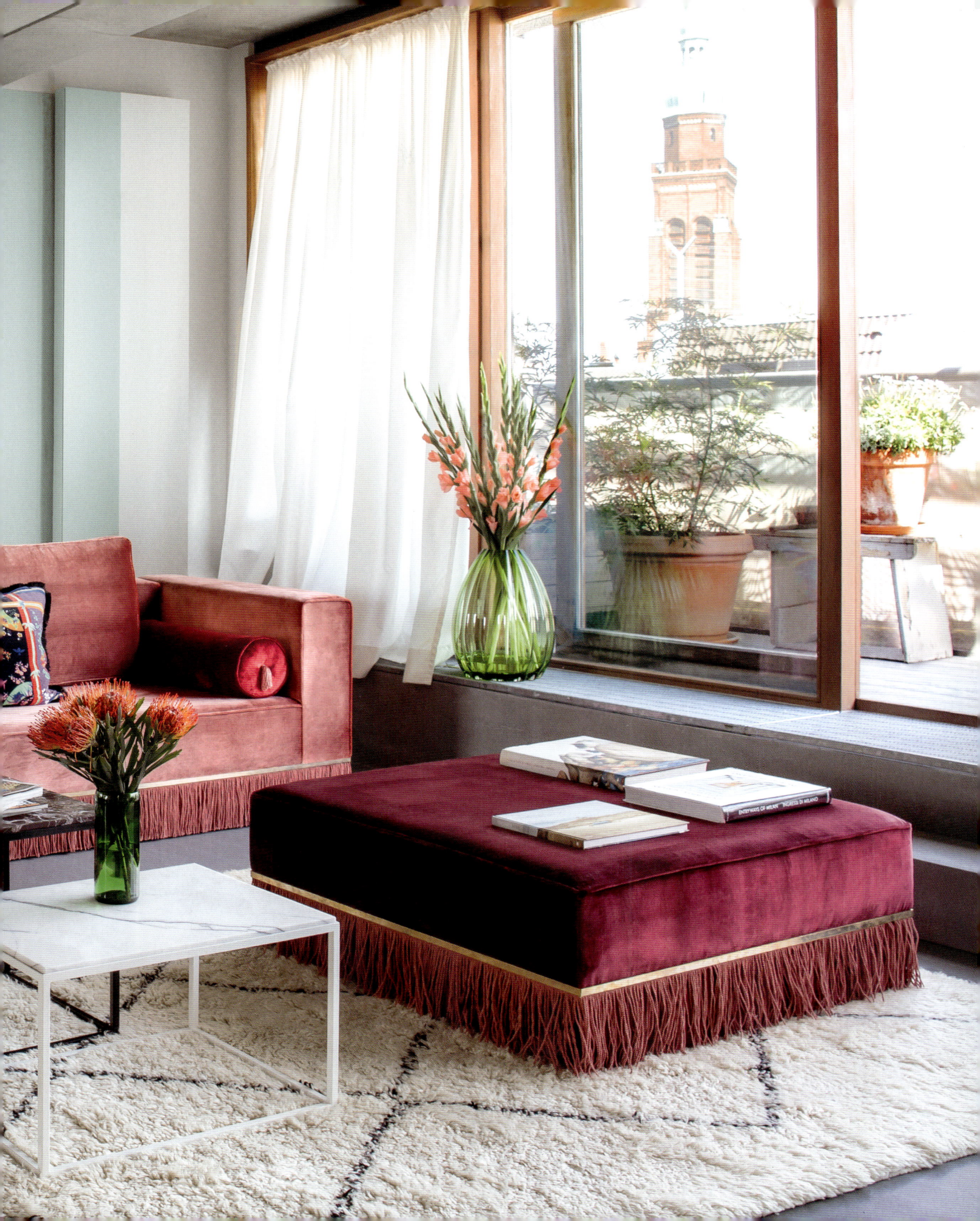

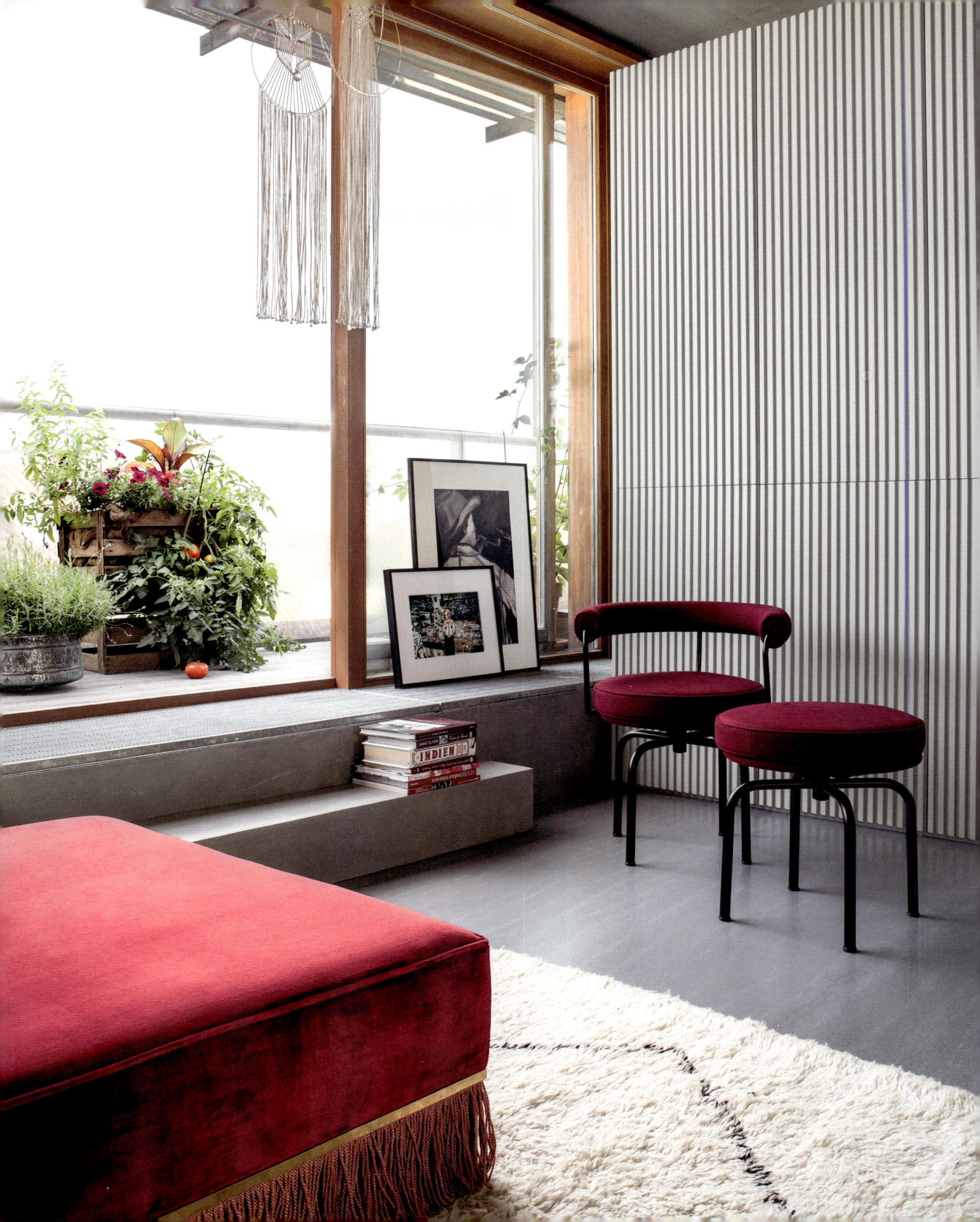

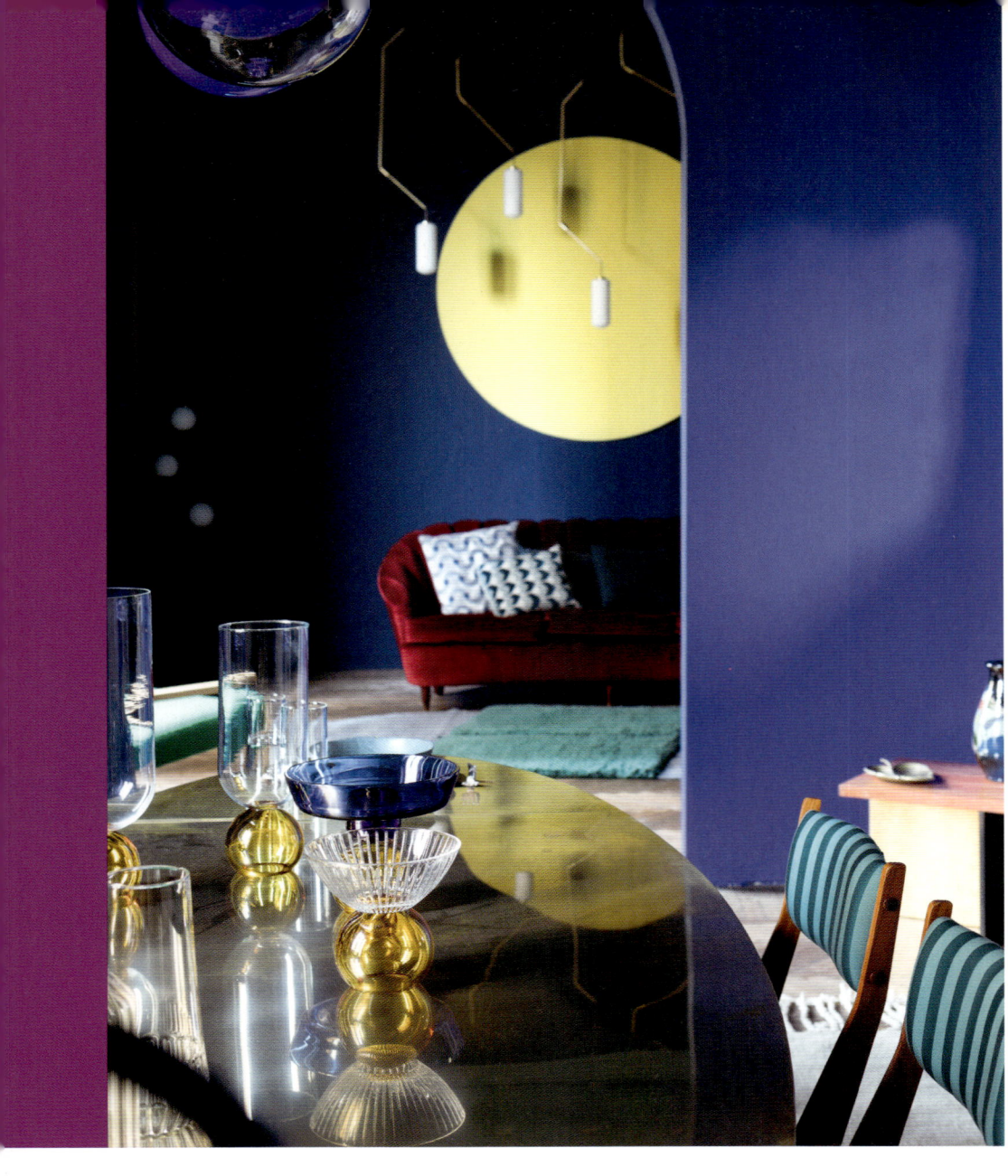

• • •

PALERMO UNO

MILAN, ITALY

DESIGNER & RESIDENT
SOPHIE WANNENES

SOPHIE'S CABINET OF WONDER

Sophie Wannenes is from a family of antique dealers that goes back five generations. Her cabinet of curiosities is her residence-cum-showroom, PalermoUno, in the Brera district of Milan—the heart of the world's most talked about furniture fair. Exploring Wannenes's home is a most memorable experience. Before embarking on this venture, she created stages for both Sotheby's and Christie's, and spent time in the advertising industry. She is no stranger, therefore, to creating scenes of show and wonder. Combined with her eye for refined furniture and decorative arts, it is a winning formula.

The 150-square-meter (1,600-square-foot) residence has a simple layout that sees six rooms feed off a generous central hallway. In renovating the place from scratch, Wannenes has imbued it with the same boho chic vibe that pervades the surrounding neighborhood. It would be impossible to ignore the striking use of color in this scheme—dark, saturated shades that range from deep purples and blue-black to an intense mustard yellow against which the exquisite furnishings gleam and glisten. "I think it's very eclectic as there are many colors, and also pretty elegant thanks to a harmonic mix between designs and centuries," says Wannenes of the look she has created.

Hers is a relaxed approach to selling that allows visitors free reign of the showroom to experience the vibe for themselves, testing out the furniture and handling ornaments for a closer look. It is a clever technique through which customers take ownership of the pieces on display without even knowing it. ◆

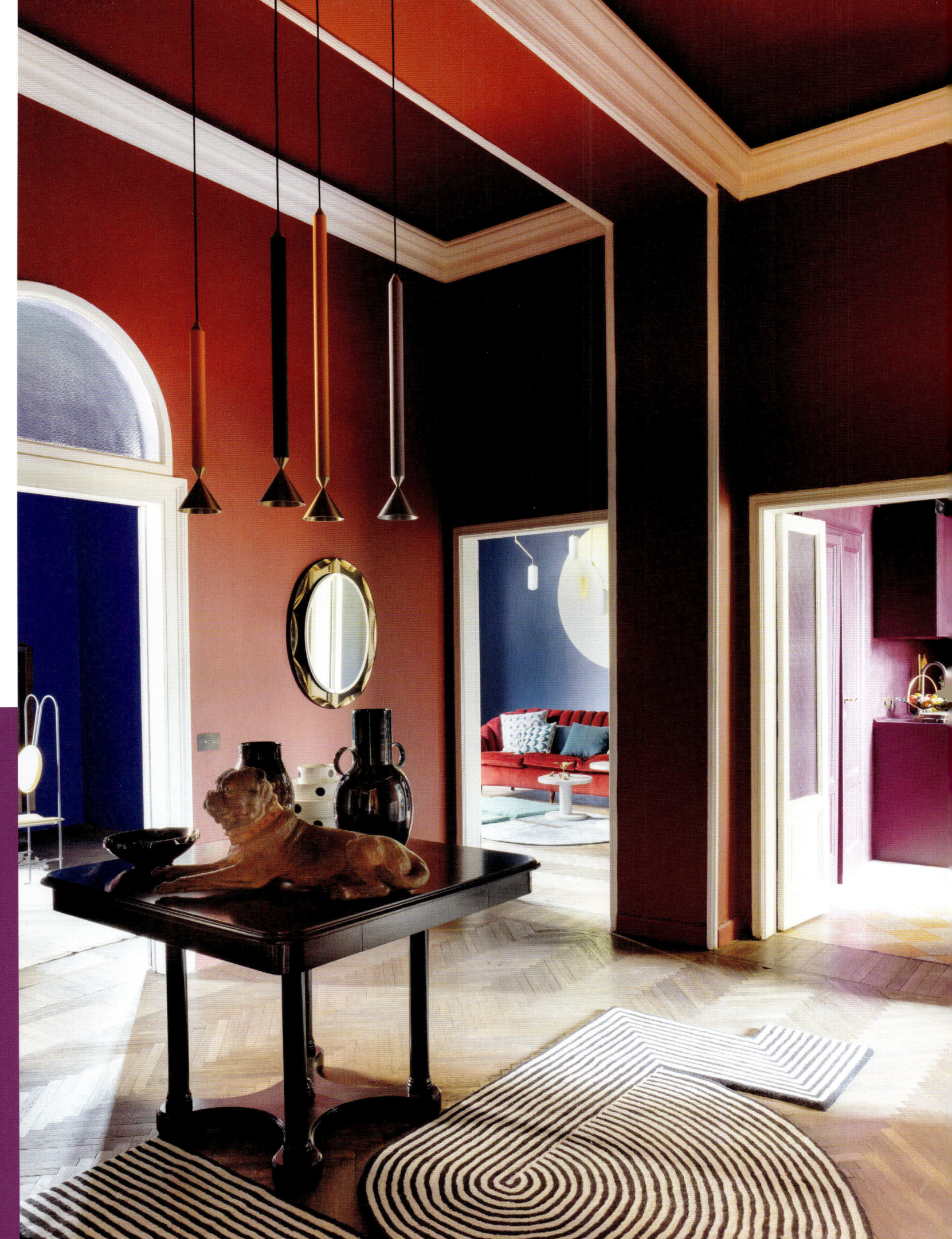

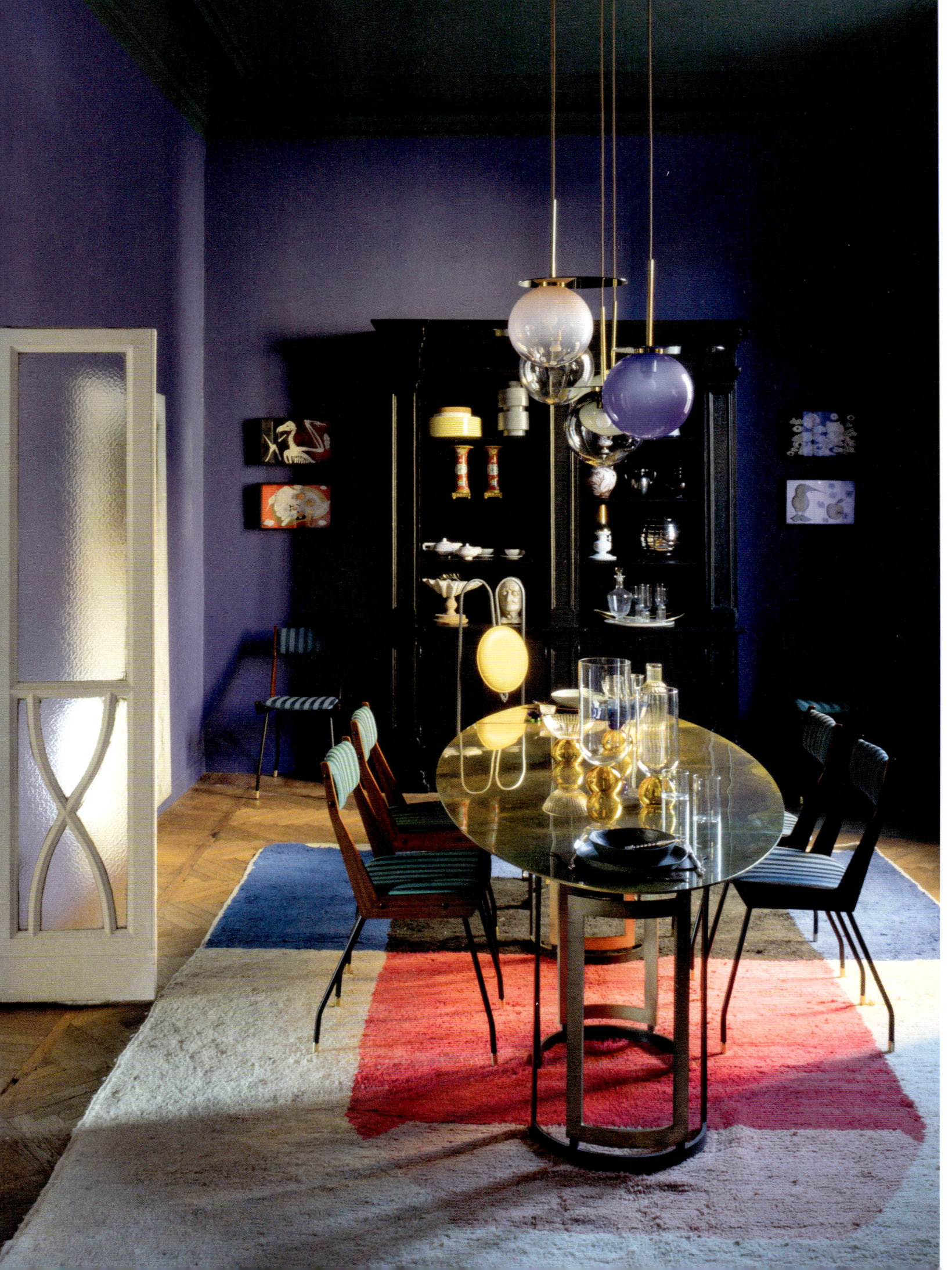

IN RENOVATING THE PLACE FROM SCRATCH, WANNENES HAS IMBUED IT WITH THE SAME BOHO CHIC VIBE THAT PERVADES THE SURROUNDING NEIGHBORHOOD.

Contemporary furnishings include chairs by Mario Milana, vases by Natalia Criado, and collages by Victor Cadene. Many of the textiles and soft furnishings, such as the cushions in the living room, are from Kirkby Design.

IT IS IMPOSSIBLE TO IGNORE THE STRIKING USE OF COLOR—DARK, SATURATED SHADES THAT RANGE FROM DEEP PURPLES AND BLUE-BLACK TO AN INTENSE MUSTARD YELLOW.

Such is Wannenes's skill at selecting furniture that it is not always apparent which pieces are contemporary and which are vintage. Almost all of the lighting is contemporary, including the lotus lamp (*left*) and Bomma lighting globes above the dining-room table. Mirrors are mostly vintage.

MINIMALI
DEFINED B
NOT THERE
RIGHTNESS
IS AND TH
WITH WHI
EXPERIENC

...SM IS NOT
... WHAT IS
... BUT BY THE
... OF WHAT
... RICHNESS
... THIS IS
... ED.

—John Pawson

ECLECTIC CREATIVE DISPLAY

TRIBECA LOFT

NEW YORK CITY, USA

DESIGNERS
ROLLMANN ARCHITECTURE &
ANTHONY SPERDUTI

RESIDENT ANTHONY SPERDUTI

Sperduti's apartment is full of unusual details that add to the layering of textures that he's so fond of. In the hallway alone (*above*), there is wood paneling to one side and a raw plaster finish to the other. The ceiling has partially exposed timberwork.

Presented with an opportunity to buy an entire floor of a late-nineteenth-century redbrick warehouse in Tribeca, New York, Anthony Sperduti did not think twice: "I have lived in New York long enough to know I wanted a classic loft ... And when I learned that the fourth floor was once Keith Haring's gallery, I was like, I don't want to live anywhere else." The building in question had, at one time, served as a major hub of the downtown underground art scene, and Sperduti, co-founder and creative director of design and branding studio Partners&Spade, relished the idea of making this his home.

Hugely excited at the prospect of the vast uninterrupted space the loft offered, Sperduti enlisted architect Henry Rollmann to help with the structural work while undertaking the interior design himself. In terms of styling, and with a predominantly brown and blue color scheme, the loft reflects an eclectic taste that pairs antique Moroccan textiles with small one-off pieces of mid-century furniture and ceramics, and large-scale custom-made items such as the sofa and Sperduti's bed. It is a scheme that is very much led by the heart and the mind, eschewing conventional interior design maxims and drawing on what Sperduti calls "interruptive moments"—the clashing textures and patterns that give the place its signature feel. Among the highlights in this respect are the crazy terrazzo tiling in the bathroom and a wonderfully asymmetric fireplace with tiled wall treatment above—both the work of Townsend Design. ◆

42

THIS SCHEME IS LED BY THE HEART AND THE MIND, ESCHEWING CONVENTIONAL INTERIOR DESIGN MAXIMS AND DRAWING ON WHAT SPERDUTI CALLS "INTERRUPTIVE MOMENTS."

Many furnishings are contemporary—for example, the shagreen table in the dining area is by Ron Seff from Todd Merrill and the sofa in the living area (*below*) is custom-made. Vintage touches include the low leather chair by Carlo Scarpa (*opposite*).

44

THE SHOE FACTORY

NORTHEAST ITALY

DESIGNERS
GIACOMO TOTTI &
ANDREA MAINO

RESIDENT ANDREA MAINO

PARADIGM OF 1950S DESIGN

What was once part of a shoe factory now serves as an elegant home and place of work for fashion photographer Andrea Maino. The interior design reflects the owner's personal creative tastes, but also those of his close friend Giacomo Totti, an architect with whom he collaborated on the scheme. The result is a cultivated blend of the photographer's more sober and somber design aesthetic, punctuated here and there by the architect's flair for color and texture.

With a passion for 1950s design, Maino was drawn to the factory on discovering that, though built at the turn of the twentieth century, the building had undergone restoration in the 1950s, including the complete remodeling of the factory owner's private residence. "I've been observing this factory for a long time," says Maino. "I knew it had been restored and that its interiors were wonderful." In managing to secure the apartment for himself, along with two additional factory rooms, Maino had the foundation for a perfect homage to mid-century design.

The live-work apartment is arranged over two floors. The more public spaces on the ground floor comprise the photographer's studio, which is accessed via a large, open lounge lined with beautifully glazed doors with pink marble architraves. An impressive staircase—also pink marble—leads from here to Maino's more private space, a collection of light, bright rooms sparsely furnished with a mix of contemporary and vintage Italian furniture and objets d'art. There is a distinct lightness of touch here, with chairs and tables adding to the airiness of the place, raised as they are on fine steel frames rather than solid plinths and heavy bases, while a hint of the exotic lies in the abundance of greenery and tropical flowers. The colors are subtle for the most part—dusky pink, slate blue, and olive green set against brilliant white walls. As such, the scheme offers the perfect backdrop against which a handful of more vibrant focal points—such as the glowing pink Totem armchair by Rossi Molinari in the ground-floor lounge area and an almost neon blue rug in the dining room—really come to life. ◆

47

THE COLORS ARE SUBTLE FOR THE MOST PART—DUSKY PINK, SLATE BLUE, AND OLIVE GREEN, SET AGAINST BRILLIANT WHITE WALLS.

———

Landmark designs from the 1950s include a Margherita rattan armchair by Franco Albini and a glass table by Cesare Lacca in the living room (*below*), and BBPR chairs, a Fratelli Reguitti bench, and Stilnovo chandelier in the dining room (*page 47*).

Andrea Maino (*standing*) and Giacomo Totti pose in a cozy alcove at one end of the living room, the steel blue walls marking a stark contrast to the brilliant white finishes elsewhere in the room. In the foreground, the soft tones of a 1960s velvet bench.

51

LAYER UPON LAYER OF COLOR

Many of the furnishings are the work of Irina Markman herself, including the painted walls in the hallway (*above*), a console in the living room, the dining-room pendant lamp and table (*page 56*), the bed in the nursery, and the kitchen set (*both page 59*).

◆ ◆ ◆

COLOR

MOSCOW, RUSSIA

DESIGNER & RESIDENT

IRINA MARKMAN

This apartment occupies rooms in a house, built in 1856, that lies in the historical center of Moscow. But there is little within that gives this away: the high ceilings with their elegant cornices, perhaps, or the paneled doors and wooden floors, but not much else. Instead, Irina Markman's carefully orchestrated, multilayered decor is resolutely twenty-first century.

Trying to unravel the process by which Markman arrived at the styling here presents something of a challenge. So cohesive is the overall look that it is difficult to know where the designer could have started. Take the living room. Three of its walls present a bold jade checkerboard design. Hanging on one of them is an abstract painting in predominantly magenta, purple, and mustard hues that find echoes in all other furnishings in the room, from the plush upholstery of the sofa and chairs to the patchwork surface of the dining table, and in a second abstract piece mounted on the adjacent wall.

It's an approach Markman employs throughout the apartment. Abstract geometric patterns daubed on the hallway walls echo the shapes and colors of vases assembled on the bookcase in the corner; in the bedroom, the tones and textures in a painting of a seminude are mirrored in the colors chosen for the bedding and even, somewhat unexpectedly, in the folds of an anatomical model that stands on the bedside table. It is with such innate skill at working with color that Markman creates intriguing rooms that are works of art in their own right. ◆

Irina Markman has an eye for diverse light fittings, which include the atom-style chandelier by Arteriors in the living room (*opposite*) and Ettore Sottsass's Callimaco floor lamp in the bedroom (*overleaf*). The tripod light in the nursery was bought from a vintage store in Munich (*page 59*).

COLOR

IRINA CREATES INTRIGUING ROOMS THAT ARE WORKS OF ART IN THEIR OWN RIGHT.

—

Several artworks are from the Art Brut Moscow gallery, including the geometric wall design in the nursery (*left*) and the Nikolay Morgunov hanging above the dining table (*page 56*). Fleamarket finds include the set of caricatures in the bedroom (*opposite*).

WHEN I WAS
WE EVER HE
WAS FUNC
FUNCTIO
FUNCTIONAL
ENOUGH. DE
ALSO BE SE
EXCITING.

— Ettore Sottsass

TEOREMA MILANESE
MILAN, ITALY
DESIGNER MARCANTE–TESTA
RESIDENTS
GUIDO ARIE PETRAROLI &
DONATELLA DI CAPRIO

AN HOMAGE TO MID-CENTURY

When Guido Arie Petraroli and Donatella Di Caprio bought this apartment in Milan, they found it little altered since its original construction in the 1960s. Enlisting the services of Turin-based designers Andrea Marcante and Adelaide Testa, they sought to create a new, contemporary home without losing sight of the building's past. And despite almost completely gutting the original apartment, Marcante-Testa has achieved just that.

The duo made a conscious decision to maintain the layout of the rooms, with a large open-plan dining/living space at one end, and a long corridor through the interior of the apartment with rooms feeding off it. Contemporary elements include an innovative brass and glass structure that separates the dining room from the hallway, and exquisite marble flooring that also covers sections of the walls. Meanwhile, mid-century echoes can be found in the jade green kitchen laminate, the wenge wood veneer in the hallway, and a range of ice cream colors, from lemon and strawberry to cappuccino and pistachio.

Throughout the scheme are clever juxtapositions of new versus old and luxury versus basic. Just one example of this can be seen in the treatment of the glass elements within the apartment. In the more showy living areas, the brass framework that cradles the dining room has panels of glass in which a layer of fine gossamer has been embedded. As you head toward the service areas at the rear of the apartment, a similar opacity is achieved through the use of more functional, cheaper wire-mesh glass. ◆

THROUGHOUT THE SCHEME ARE CLEVER JUXTAPOSITIONS OF NEW VERSUS OLD AND LUXURY VERSUS BASIC.

—

TEOREMA MILANESE

68

The design duo Marcante–Testa has made much of the circle motif in this scheme. A relief on the living-room ceiling sets the tone. Below it, and throughout the apartment, circular forms echo in the rug, bathroom mirror, light fittings, and the tops of side tables.

TEOREMA MILANESE

SOMETHING FROM NOTHING

Standout pieces in Breivo's interior include a Kelly Wearstler chandelier and round coffee table in the living room (*opposite*). In the hallway is a pouf made by Loffilab, to a design by Breivo herself (*above*). Loffilab also made the armchairs in the living room.

MOSCOW MULTI-STORY
MOSCOW, RUSSIA
DESIGNER KSENIA BREIVO

The "nothing" here really is the shell of the apartment itself, a 105-square-meter (1,130-square-foot) two-bedroom residence on the twenty-first floor of a turn of the twenty-first-century tower block. According to Moscow interior designer Ksenia Breivo, the building "gave no prompts or hints and kept silence." The brief from the client—an expert in art and architecture themselves—was to "create France." It was a tall order. In essence, the layout of the scheme incorporates a kitchen/dining zone, living room, main bedroom, child's bedroom, and two bathrooms. Each area is treated with the same light touch, introducing small, airy pieces of furniture to maximize on space and light.

Wherever possible, Breivo has introduced what she calls a "wave" to break up the rigidity of the rooms, both structurally and decoratively. Doorways between the main areas have inward-curving frames, while the ceilings slope gently to meet the walls at the edges of the rooms. She has also chosen furniture specifically to echo this wave—the curvy living-room sofa and round coffee table, for example—and although the flooring is original, it was removed in its entirety, restored, and replaced with the new layout. Of course, even Breivo cannot claim to have recreated Versailles in this lofty space, but there is a definite French vibe—a hint of Gallic lifestyle, pleasure, and leisure—in her carefully selected furnishings, textiles, colors, and patterns. ◆

DAVID

Packing eclectic designs
into NY townhouses and LA villas,
curator David Alhadeff
ensures each of his residential
gallery spaces are more than the
sum of their parts.

ALHADEFF

77

DAVID ALHADEFF

Wandering around the recently opened Casa Perfect gallery in New York's West Village, one encounters room after room containing an enchanting barrage of design objects. From the dark basement kitchen to the light-filled stairwell that connects the five levels of the townhouse, every space is carefully arranged with pieces that simultaneously offset and complement one another. In a bedroom, shaggy multi-hued textiles by Adam Pogue provide a backdrop for angular metal lighting by Bec Brittain, while Arnout Visser's lamps shaped like giant mushrooms sit in a nook side-by-side with boxy Lazzarini Pickering armchairs—all part of the meticulously curated "sets" assembled by founder David Alhadeff and his team.

When Alhadeff started The Future Perfect gallery in Brooklyn 16 years ago, it primarily exhibited contemporary American design, and particularly championed local designers, at a time when the area was, by chance, experiencing a creative boom. The wide variety of individual styles emerging from the New York borough, fuelled in part by a surge of interest in craft following the 2008 financial crisis, helped to lift the gallery's profile and shape its eclectic approach to curation.

This was also a reaction to the minimalist, all-encompassing Dwell look that dominated the beginning of the century. At that time, buyers would come to The Future Perfect and purchase a single piece that would blend and match with their aesthetic, according to Alhadeff, who has, over the years, witnessed first-hand how tastes and buying habits have shifted. "Eclecticism is really what I see as pervasive [now]," he says. "As people get increasingly intelligent about buying design as a part of their collection, they're thinking a lot less about making sure everything balances and fits in a room. I've watched people who were really familiar with the beige or gray of the early 2000s get really comfortable with color."

Nowadays, collectors are much more comfortable pairing Piet Hein Eek tables with Charlotte Perriand chairs, or displaying multiple pieces from designers with very varied styles all in the same space. "Now, it seems to be the assemblage is very much about layering," Aldaheff continues. "It's about historical work being mixed with contemporary work, and really being about the taste of the particular client, or the interior designer imbuing their taste into a project."

Although the gallery's focus on the contemporary has largely remained, its pool of talent has expanded internationally, and The Future Perfect now carries work by some of the biggest names in the industry—Dimore Studio, Neri&Hu, and Lindsey Adelman, to name a few. "There's no particular overarching trend in an overall sense of aesthetics," says Alhadeff of his ever-evolving roster. This is no more evident than at The Future Perfect's Casas—a concept that Alhadeff introduced in Los Angeles in 2017, adding to his outposts in Manhattan (which he left Brooklyn for in 2009) and San Francisco, which opened in 2013.

The appointment-only Casa Perfect spaces have allowed the gallery to explore a new way of presenting design: scattering its myriad retail products across complete residential settings, where Alhadeff is able to curate the designs into intimate vignettes of starkly contrasting colors, materials, and styles. The concept is a response to a sophisticated market and a clientele that does not need a "white box" setting in order to appreciate the offering. "It's an opportunity for us to layer the work and to create juxtaposition," says Alhadeff, who also lives and works in the properties in Los Angeles and New York City when staying on either coast. "It is less interior than it is editorial."

> "ECLECTICISM IS REALLY WHAT I SEE AS PERVASIVE."

The design eclecticism that The Future Perfect purveys follows what art collectors have been doing for generations—blending periods, media, and styles into collections that reflect the tastes of their owners. "Interior designers that we're working with are thinking about design as art," says Alhadeff. "What they're doing with clients is less about furnishing rooms and more about building a body of work. [Art] is coming off the walls, and it's landing on the rug, in the stool, on the table, in the fabric."

Alhadeff is also using art to enhance and elevate the designs he is selling. The Los Angeles Casa Perfect, which occupies a mid-century Beverly Hills villa once owned by Elvis Presley, recently hosted an exhibition of Andy Warhol paintings. Hanging the iconic art beside contemporary designs created an ideal juxtaposition in Alhadeff's eyes. "Given the context of the architecture, Warhol's work made perfect sense in the storytelling and it became part of the layering," he says.

Alhadeff, however, believes that fashion, not art, is having more of an impact on the current "bold interiors" movement. He cited the wide assortment of prints and motifs compiled by Gucci creative director Alessandro Michele into the brand's recent collections as a taste of things to come for furniture and home design. "Fashion paves the way for the eye to get used to certain things, and there couldn't be more mixing of patterns and color... It may mean that we've only just scratched the surface of all of this 'maximalism.' Stripes and polka dots, and florals are all yet to be in the same room, and are about to be."

Social media, he says, has also played a part in training us to consume a barrage of visual information, and differentiate one design from another, very quickly. "When we go into spaces that feel really eclectic, they no longer feel overwhelming compared to 10 years ago," says Alhadeff, who admits that the rooms at the Casa Perfect locations are arranged primarily for photography that is ripe to be shared. He likens the private-feeling spaces of the properties to "sets" in which pieces by emerging Brooklyn-based designers such as Chen Chen & Kai Williams, Bower Studios, and Ladies & Gentlemen are gathered as they were in his original gallery. But just because he lives with the pieces in this way does not mean he thinks that anyone else necessarily has to. "We're not professing that that's how you should live with the work. We're simply professing it as an opportunity to create conversation." Based on the response the Casas have received since opening, The Future Perfect has certainly succeeding in getting the design world talking. ◆

DAVID ALHADEFF

"THERE'S NO PARTICULAR OVERARCHING TREND IN AESTHETICS"

Chris Wolston's work lends an organic exuberance to this seemingly minimalist interior. Below the mass of palm fronds in his Tropical Chandelier, a jumble of aluminum limbs form the surface of his Orgy coffee table (*left*).

In this sedate room within the Casa New York, a table and chairs designed by Jason Miller stand on a Surya Rug with a 50s vibe by Atelier Fevrier. The "chain" style lighting is the work of Franz West and dates from the late 1980s (*below*).

Bec Brittain's Maxhedron pendant light hangs above a patinated brass Chamfer coffee table by Christopher Stuart. Softening their angular forms is an elegant Inge sofa from Marta Sala Editions (*page 78*).

"PEOPLE GET INCREASINGLY INTELLIGENT ABOUT BUYING DESIGN AS A PART OF THEIR COLLECTION."

The two tables pictured here, the Twist and Striker, are the creation of Floris Wubben. Highly original and crafted from ceramic, their bold forms resemble machinery (*above*).
A colorful collection of sculptures and vessels from the Materialism collection of works by George Snowden and Nathalie du Pasquier for Memphis Post Design (*far left*).
A trio of stunning, glass-blown Big Mushroom floor lamps by Netherlands-based glass artist Arnout Visser stands on a rug by Atelier Fevrier (*left*).
At Casa New York, a Lek sofa by Christophe Delcourt mirrors the curve of his wooden hub table. The color scheme in this room is predominantly gray with white light fittings by Eric Roinestad, and copper-hued sculptural pieces and drinks cabinets by Marcin Rusak (*pages 82–83*).

DAVID ALHADEFF

At Casa New York, an elegant pair of green geometric lounge chairs by Dimore Studio sit beneath Michael Anastassiades's curvaceaous Mobile Chandelier (*below*).

A colorful ceramic piece by Reinaldo Sanguino sits newly unwrapped on the richly veined marble kitchen worktop (*opposite, above*).

In the bedroom, soft beige curtains and wallpaper by Calico offer a neutral backdrop for the striking bed comforter by Adam Pogue. On the wall is a sleek, gold-plated beauty mirror by Michael Anastassiades (*opposite, below*).

87

HOLLYWOOD GLAMOR REBORN

Adler excels at achieving just the right level of vintage by introducing graphics (*above*), ceramics (*page 93*), geometric shapes (*page 93*), and textiles in retro colors (*opposite*), all of which contribute to a 1960s vibe throughout the scheme.

◆ ◆ ◆

PARKER PALM SPRINGS
PALM SPRINGS, USA
DESIGNER JONATHAN ADLER

What is now the Parker Palm Springs was originally built in 1959 as California's first Holiday Inn. The hotel has seen various incarnations since then, not least an earlier revamp by Jonathan Adler in 2004. This celebrated interior designer has forged a career in many areas of design since launching his first ceramic collection at Barneys New York in 1993. Today, he is best known for an eclectic design oeuvre that includes furniture, lighting, and soft furnishings. When revisiting the hotel for this latest makeover, Adler, who is renowned for his wit and whimsy, felt compelled to give the place a contemporary update while bolstering the Hollywood glamor that has lured residents for decades.

Perhaps the most talked about Adler addition to Parker Palm Springs is the the 2.1-meter, 408-kilogram (7-foot-tall, 900-pound) half-peeled bronze banana that he has planted on the main lawn—the designer's first public sculpture. Inside, the hotel's communal parts exude Hollywood chintz: tall brass palm trees flank the turquoise velvet doors that mark the entrance to the residents' bar; plush, voluptuous sofas beckon visitors to lounge in a nautical-themed foyer; and a stair runner based on flooring from the Overlook Hotel in *The Shining* leads to the floor above.

The designer's signature styling culminates in the Gene Autry Residence, a villa that once served as the cowboy country singer's home. Summing up what Adler considers to be the "fantasy of a Palm Springs getaway," the rooms abound with graphic prints, geometric textiles, and a fine collection of African tribal masks. The dining room features a burled wood table paired with brass and orange wool-upholstered chairs. It is in the bedrooms here that Adler's styling has a more contemporary feel. Crisp linens in white and taupe grace blackened limed-oak beds set against whitewashed brick walls and rush carpeting. Outside, a pool area is surrounded by the city's eponymous palms, and features a run of elegant private cabanas clad in blue and white. ◆

Adler always strikes the right note. The lobby (*opposite*) is louche and bright, the Gene Autry Residence (*above*) is sedate in its orange, taupe, and tan shades, and the Palm Springs Yacht Club on the estate is decorated throughout in blue and white (*pages 90–91*).

PARKER PALM SPRINGS

Adler is renowned
for his wit and whimsy.

PARKER PALM SPRINGS

ALWAYS DES
BY CONSIDE
NEXT LARGE
A CHAIR IN
ROOM IN A HO
IN AN ENV
AN ENVIRO
CITY PLAN.

GN A THING
NG IT IN ITS
R CONTEXT—
A ROOM, A
USE, A HOUSE
RONMENT,
MENT IN A

—Eliel Saarinen

OLD
FLORIDA
STYLE

Caminos has done much to emphasize the original Spanish colonial architecture, maintaining the neutral façades on the exterior (*opposite*) and restoring the internal exposed-beam ceilings, tiled floors, and arched doorways and windows (*above and pages 104–105*).

LA CASA DE LAS FUENTES
MIAMI BEACH, USA
DESIGNER
XIMENA CAMINOS
RESIDENTS
THE CAMINOS FAMILY

In recent years, Argentinian-born Ximena Caminos has become a leading light in Miami's art scene, which has seen a vibrant resurgence since the turn of the twenty-first century. Arriving in 2014, Caminos was involved in developing, styling, and running the hugely successful Faena Forum, a complex comprising a luxury hotel, private residences, and a cultural center. Having gone on to establish her own creative agency, Honey Labs, Caminos then worked in collaboration with Art Basel to establish a similar enterprise, the Blue Heron Ocean Society, which is located at the old Savoy Hotel.

Caminos has an innate talent for interior design, as is evident in the house she devised for her and her family to live in. Falling for a typical 1930s Miami Beach estate, Caminos set about recreating the quintessential "Old Florida" vibe that one immediately associates with the Sunshine State. Dominating the look was the Hollywood regency style that emanated originally from California in the 1920s and was faithfully emulated in Miami's old Palm Beach neighborhood.

The striking house is typical of the Spanish colonial revival style of the 1930s, complete with missionary-style tower, red pantiles on the roof, and an arcaded walkway fronting the outdoor pool: "When I bought this 1930s estate, I could see it had great bones but it had been destroyed by many years of bad architecture and design," says Caminos. Inside, in the stylist's own words, the rooms present "an alchemic cocktail of colorful mixes, tropical gardens, and collector pieces." True to classic Hollywood style, typical features are the elegant cloud-back sofas and rattan chairs, hand-painted wallpapers and murals with bold designs, exquisite mirrored and lacquered furniture, and textiles brimming with florals and animal prints. Colors are predominantly pinks, greens, and ivory, offset with brass. And, of course, in the sunny courtyard beyond, there is no shortage of luscious palm trees. ◆

LA CASA DE LAS FUENTES

102

CAMINOS SET ABOUT RECREATING THE QUINTESSENTIAL "OLD FLORIDA" VIBE THAT ONE IMMEDIATELY ASSOCIATES WITH THE SUNSHINE STATE.

Caminos has worked hard to furnish the palatial rooms tastefully and to scale. A monumental table dominates the green-themed dining room (*pages 100–101*), voluminous sofas and armchairs occupy the living rooms (*pages 104–105*), and huge artworks hang on the walls (*below*).

LA CASA DE LAS FUENTES

The Hollywood Regency styling would be incomplete without the brass and gilt finishes that Caminos has peppered throughout—from the exquisite palm-leaf lamp in the dining room (*pages 100–101*) to the side cabinet in the living room (*above*) and multiple accents in soft furnishings and ornaments.

INSIDE, IN THE STYLIST'S OWN WORDS, THE ROOMS PRESENT "AN ALCHEMIC COCKTAIL OF COLORFUL MIXES, TROPICAL GARDENS, AND COLLECTOR PIECES."

LA CASA DE LAS FUENTES

LA CASA DE LAS FUENTES

♦♦♦

PASEO DE LOS LAGOS
MADRID, SPAIN
DESIGNER L.A. STUDIO

AN ARTY BALANCE

For its VIP Room at the Arco International Contemporary Art Fair in Madrid, L.A. Studio assembled a bold selection of twentieth- and twenty-first-century furnishings against a bright and busy wallpaper titled Arty by Pierre Frey. The ensemble attracted the attention of a serious collector of contemporary art looking to commission the interior design of a property in Madrid. Hoping to extend his collection into the field of design, he recognized L.A. Studio's ability to achieve just the balance he was looking for.

Under the direction of founder Carlos López, L.A. Studio set about creating a series of spaces in which art and design were brought together seamlessly to achieve what López describes as "a cozy atmosphere but not with the meaning of 'normal' or 'common' as in with no personality." In fact, personality is key here, with L.A. Studio selecting pieces that made a statement in their own right and yet none of which seem to dominate the scheme. They include Willy Rizzo's Middle Moon molded steel coffee table, a Murano glass-clad sideboard with brass legs, and a pair of Poliedri wall lights by Carlo Scarpa.

There is also a pair of doors and a sofa upholstered in a variant of Frey's Arty design. They sum up L.A. Studio's claim to feature "arty" elements, by which López means "objects whose aesthetic is established halfway between art and design." These are the pieces that most successfully cultivate the link between furniture and art, keeping that balance in which neither of the two fields is subordinated to the other. ♦

L.A. Studio called upon a diverse collection of furniture designs. These range from mid-century classics, such as Marco Zanuso's Lady chair (*opposite*), and typical Memphis creations, that include Ettore Sottsass's Treetops floor lamp, to designs the studio have issued themselves, such as the three-set coffee table (*both page 119*).

PASEO DE LOS LAGOS

PASEO DE LOS LAGOS

> PERSONALITY IS KEY HERE, WITH L.A. STUDIO SELECTING PIECES THAT MADE A STATEMENT IN THEIR OWN RIGHT.

—

Every room sparkles with Murano glass. Besides the glass-clad sideboard (*page 117*) are door handles commissioned by L.A. Studio using antique Murano pieces and fabulous chandeliers by Venini (*pages 112 and 117*), as well as an exquisite pair of leaf-shaped wall lights (*below*) and a table lamp made of brass and Murano glass spheres (*opposite*).

I WONDER IF A
OF INTERIO
MORE PERS
COLOR? NO
MORE QUIC
ASPECT OF
THAN THE
ABSENCE—OF

"ANY ELEMENT OF DESIGN IS MORE PERSONAL THAN ANYTHING CAN POSSIBLY REVEAL PERSONALITY OF CHOICE — OR COLOR."

—Van Day Truex

GREENWICH VILLAGE APARTMENT
NEW YORK CITY, USA
DESIGNER JONATHAN ADLER
RESIDENTS
JONATHAN ADLER &
SIMON DOONAN

NOT SHORT ON GLITZ

"Flamboyant" is a word that springs to mind when guessing at the decor of Jonathan Adler and Simon Doonan's Greenwich Village home. Let's face it, this is a highly creative duo—Doonan being the designer of some of Barneys's most memorable window displays, and Adler a hugely successful homewares designer and stylist. And do not forget the entire scheme is the work of Adler himself. So of course you can expect glitz and glamor as you trip from one room to the next, but there is also a good measure of class, refinement, and charm. In the foyer, for example, a stunning golden console designed by Adler takes center stage in a predominantly black-and-white scheme punctuated with rich brass and copper tones. Soft, neutral shades also dominate in the kitchen, where warm gray cabinetry nestles in a wall of richly veined marble above a black slate floor.

Step into the living room, the bedroom, or the couple's study, however, and the true energy of the place hits you. An impressive double-height space with a gently vaulted ceiling and huge multi-paned window, the living room is bright and airy with a bold black-and-white checkered floor and two Vladimir Kagan sofas newly reupholstered in an ivory bouclé. Lining the marble mantelpiece is a collection of quirky vintage Italian glass figurines in colors that find echoes throughout the room: in the green velvet upholstery of a Joe Colombo Elda chair, the mustard-colored drapes, and in blue sconces above the fireplace (an Adler design). Even more colorful is the library. Painted a deep blue, the narrow space is furnished with a rich gold-velvet buttoned sofa, a shaggy magenta rug, and even the ceiling is lined in luminous wallpaper designed by David Hicks. Additional pops of vibrant color reside in a run of plates by LeRoy Neiman and a bunch of busy-patterned scatter cushions. And if, as you step into the bedroom, you feel as if you are being watched, you are not mistaken— there are eyes everywhere. ◆

EXPECT GLITZ AND GLAMOR AS YOU TRIP FROM ONE ROOM TO THE NEXT, BUT ALSO A GOOD MEASURE OF REFINEMENT AND CHARM.

The sheer wealth of furnishings is staggering. In the dining room stands a gold hand chair by Pedro Friedeberg (*pages 124–125*), in the bathroom is a custom tub by Apaiser (*page 139*), and in the living room is a screen by Piero Fornasetti (*above*).

126

129

130

GREENWICH VILLAGE APARTMENT

Both the kitchen (*opposite*) and the bathroom (*right*) offer more restful vistas. The gray cabinetry in the kitchen is custom-made and features hardware designed by Adler. In the bathroom, the blue wall tiles and white floor tiles give the room a more classic feel.

133

POLYCHROME HOUSE
SYDNEY, AUSTRALIA
DESIGNER AMBER ROAD DESIGN

REKINDLING THAT 1960S VIBE

A subtle reworking of a 1960s beachside home, Polychrome House is a happy meeting of architecture, art, and design. Located in the Cronulla suburb of Sydney, it is the work of Amber Road Design, headed by sisters Katy Svalbe and Yasmine Ghoniem. The main thrust of the refurbishment was to extend the ground floor to align with a balcony on the floor above. The kitchen was also moved from up- to downstairs, and works with an unconventional layout that sees a brick plinth function as lounge seating, cooking island, and open liquor display all in one. The effect of this was to shift the whole focus of the home, allowing the social spaces to take center stage. Upstairs, what had been the kitchen was remodeled as a study with a mezzanine-level guest room and en suite, essentially upgrading the house from a two to a three bed.

The greatest triumph in this refurbishment lies in the collaboration with Lymesmith, a design practice founded by Sonia van de Haar that works specifically with color within the architectural environment. Under van de Haar's direction, Amber Road Design kept the original exposed brickwork that is so much a part of the original 1960s home, and layered a bold, primary color palette throughout the ground floor, described by co-director Yasmine Ghoniem as "the heartbeat of the 'joyful' experience we were all committed to creating." To complement this, Lymesmith produced abstract artworks for the walls, loosely resembling aerial views of the surrounding terrain. In a conscious effort to maintain the 1960s vibe, the architects finished the decor with a rugged, almost jet black crazy paving that covers the entire ground floor inside and out. ◆

LYMESMITH PRODUCED ABSTRACT ARTWORKS FOR THE WALLS, LOOSELY RESEMBLING AERIAL VIEWS OF THE SURROUNDING TERRAIN.

—

The colors may be bold at Polychrome House, but they are also earthy. The reds veer toward terra cotta, greens toward sage, and yellows are mustardy. Furnishings are simple and pattern is sparse, allowing for the art to take center stage.

138

INNOVATION
THE ABILITY
INTO THE
BRING BA
IS GOOD
BEAUTIFU
IS USEFUL
LASTING.

…IS OFTEN
… TO REACH
…AST AND
…CK WHAT
… WHAT IS
…, WHAT
… WHAT IS

—*Sister Parish*

PARIS ÉTOILE
PARIS, FRANCE
DESIGNER ROUGE ABSOLU
RESIDENT GÉRALDINE PRIEUR

A RIOT OF BRIGHT COLOR

With the Saudi royal household and the Kennedy family as past clients, Géraldine Prieur is no stranger to opulence—but there is a novel twist to the unique style that this Parisian interior designer has crafted for herself. Having founded her own brand Rouge Absolu in 2012, in Prieur's own words: "Her creed is harmony. Her inspiration is visionary. Her life is guided by unconventional full colors."

There is no better way to comprehend Prieur's creed than to visit one of her exceptional interiors—in this case, an apartment in a grand nineteenth-century Haussmann building in the heart of Paris. There is a whimsical yet highly sophisticated artistry at play here—something the designer herself describes as "controlled eccentricity." Rather than ignore the history of the place, Prieur has instead incorporated its original features into inimitable styling. And so, against a neoclassical backdrop of fine wood paneling, marble fireplaces, ornate moldings, and decorative stained glass, each room is a riot of hues filled with the most luxurious ultra-contemporary furnishings.

It comes as no surprise to learn that Prieur draws inspiration from the world of fashion—her colors are bold, her decorative features larger than life. Each room is dominated by a powerful scheme of unexpected shades: sulfur yellow and cobalt blue for the dining room, midnight blue with dusky rose for the living room, and emerald green for the bedroom. With rooms that ooze glamor, sensuality, ostentation, and sophistication, in Prieur's world there is no space for the mundane. ◆

Several elements of this interior are the creations of Géraldine Prieur herself, not least the Rose Pommette color with which she has painted the living room (*opposite*). Furnishings designed by Prieur include the red-lacquered bookcase and walnut coffee table in the living room, and the rug in the more sedate salon (*page 147*).

147

PARIS ÉTOILE

151

EACH ROOM
IS DOMINATED
BY A
POWERFUL
SCHEME
OF
UNEXPECTED
SHADES.

—

ACCENTS OF COLOR

OSBORNE BUILDING RESIDENCE
NEW YORK CITY, USA
DESIGNER REUNION GOODS & SERVICES

The spaces in this midtown apartment are extremely generous—fantastic proportions and super-high ceilings. Floors are lined with exquisite parquet panels, with fine duotone detailing and intricate inlays. Internal doors have glazed sections, making the most of the natural light.

Two blocks south of New York's Central Park, the Osborne is one of the great apartment blocks of the Gilded Age—a period of rapid economic boom in the last quarter of the nineteenth century. Testimony to the riches of the time (in certain quarters, at least), the rooms of this apartment are vast, with generous ceiling heights and no shortage of glazing. Typical original architectural details include fine moldings, elegant wood-paneled doors, and deep baseboards. Commissioned to refurbish the apartment for a young family, the design team at Reunion Goods & Services sought to restore the best of the classic details while creating an environment that was chic but comfortable, sophisticated but fun.

There was just one obstacle: of the client couple, one wanted color to dominate, while the other favored pure white. The design that evolved is a clever one. After removing the furnishings from the finished apartment, the rooms were painted brilliant white throughout, with the exception of a few tastefully selected wallpapers. Set off against the honey-colored parquet flooring, the look is one of sophistication and serenity. The furnishings were then reintroduced one by one, and their bright pops of color brought the spaces to life. In the living room is a soft-pink Pierre Paulin Pumpkin sofa and a *Sky Series* photo by Eric Cahan—a deep saturated blue. In the dining room a resin-slab dining table is surrounded by brightly colored chairs, while Reunion's own blue powder-coated washstand graces the bathroom. Even the wallpapers by Eley Kishimoto are reserved for a few select surfaces. ◆

THE FURNISHINGS WERE
REINTRODUCED ONE BY ONE,
AND THEIR BRIGHT POPS
OF COLOR BROUGHT THE
SPACES TO LIFE.

—

The neat screen-printed wallpapers are produced by fashion and interiors studio Eley Kishimoto, who print them by hand in their London studio. They have cute names to match their designs: Monster Skin in the bathroom and Fishbone Borders in the dining room.

A Piece
of Memphis
in Maui

While Olabuenaga designed the Basic coffee table (*above*), most of the furnishings are by Sottsass, including the Hawaiian Koa lounge chairs and Hyatt side tables (*opposite*), the niche display (*page 163*), and the Giotto shelves, Treetops floor lamp, and Olivetti chair in the study (*page 162*).

♦ ♦ ♦

CASA OLABUENAGA

MAUI, USA

DESIGNER ETTORE SOTTSASS

RESIDENTS ADRIAN OLABUENAGA & LESLEY BAILEY

Since establishing their accessories business Acme Studio in 1985, Adrian Olabuenaga and Lesley Bailey have launched some of the most memorable writing instruments of the past three decades through collaborations with many of the world's leading designers. The roll call of artists who have worked with Acme is staggering and includes Michael Graves, Keith Haring, Andy Warhol, and Karim Rashid, among many, many others.

Acme's first major collaboration was with the Memphis designers, a loose group of artists spearheaded by Italian architect and designer Ettore Sottsass, who the couple commissioned to design a house for them in 1988. Completed in 1997, the property sits on the slopes of Mount Haleakalā, in Maui's highly sought-after Kula district. Arranged on two floors, the house was—and remains—pure Memphis through and through. It comprises a series of volumes, finished in green, yellow, and brown, contained within a black frame. At one end stands a bright-red tower with a pitched roof. Beyond the Romanesque-arched front door (also red), rooms are furnished almost exclusively with pieces designed by Sottsass, many of them specifically for this residence; in a recent magazine article on the couple, they were seen to be eating lunch using his flatware and crockery.

Although Sottsass was responsible for most of the design, including the choice of colors for the exterior, Olabuenaga and Bailey collaborated with him throughout the build, from the initial sketches up until the home's completion. Sottsass worked with Bailey to choose the color scheme in the kitchen, for example. And if the couple requested changes, he found a way to accommodate them—including the remodeling of an early plan for two bedrooms to accommodate three. Today, on show in the study is a model of the house, created by Sottsass at the very start of the project, alongside original drawings for the scheme. No doubt they are collector's items now, as is the house, which was recently valued at almost 10 million US dollars. ♦

ARRANGED ON TWO FLOORS, THE HOUSE WAS—AND REMAINS— PURE MEMPHIS THROUGH AND THROUGH.

CASA OLABUENAGA

163

CASA OLABUENAGA

ECHOES OF MEMPHIS

Colors are flat and devoid of ornamentation. Much of the success of the scheme lies in the care that the team from Studio Rhonda has taken in using just one tone of each color, no matter whether the finish is tiled, painted, or upholstered.

YORK WAY
LONDON, UK
DESIGNER STUDIO RHONDA

Reminiscent of the vibrant Memphis Milano style that epitomized the postmodernism of the 1980s under the direction of Ettore Sottsass, this refurbishment of a central London penthouse is awash with colorful geometric motifs. Central to the scheme by Studio Rhonda are the 2,000-plus pigmented concrete tiles that grace many surfaces, not least a fully bespoke hand-built kitchen and bathroom. Crucial to the success of this styling is that all of the tiles have exactly the same dimensions. As such, although the colors change from one surface to the next, there is a uniformity of scale, an essential element in making small spaces appear bigger. The dominant tile color is a steel gray, which lends a certain industrial edge to the look, particularly in the open-plan kitchen, where it is married with brilliant white shelving.

 Throughout, additional tiled details pop in rose pink, grass green, sunshine yellow, and royal blue. Many of the apartment's soft furnishings mirror these tones, as do the doors to each of the rooms—every one a different flat color. In the living room and bedroom, the walls are painted with deep, alternating stripes of gray and white. The geometric theme continues in the numerous concrete planters—both inside the flat and on the decked area outside—that have been daubed with triangles, circles, and rectangles in the same pink, green, and yellow. And again, those same colors are captured in a geometric mural in the living room. ◆

166

CENTRAL TO THIS SCHEME ARE THE 2,000-PLUS PIGMENTED CONCRETE TILES THAT GRACE MANY SURFACES.

NINA

A famous design dealer in Milan, Nina Yashar has an insatiable curiosity for historical and contemporary objects alike.

YASHAR

169

NINA YASHAR

Nina Yashar is Milan's foremost dealer in design, with a keen eye for both new talent and old masters. When walking through any of the timeless exhibitions at her gallery, Nilufar, it is not always easy to differentiate between present day and vintage objects. Founded by Yashar in the late 1990s, and named in homage to her sister Nilu, with whom she runs the gallery, their manifesto is: "Discovering, crossing, creating." Yashar's insatiable curiosity has shaped the gallery's distinct aesthetic of unexpected pieces, which mix a love of historical and mid-century styles with the evolution of contemporary design, a cross-temporal and cross-cultural approach that is very much in tune with today's zeitgeist.

While wandering through her shows, you may be able to distinguish the tiered smoothness of a 1955 white-lacquered perforated metal lamp by Finish designer Alvar Aalto, the branch-like patterned designs of a 1972 to 1975 hand-knotted wool carpet by Emilio Pucci, the 2008 stainless steel Mirage tables by Indian designer Rajiv Saini—which look like bleeding puddles—or the 2007 ceramic cake sculptures of American artist Amy Lowry, and yet some pieces will inevitably confuse you and keep you guessing. Yashar is fascinated not only with the aesthetics of such works, but also their phenomenological presence in relation to the viewer.

"DISCOVERING, CROSSING, CREATING."

As one of the main exponents of such a hybrid aesthetic, Yashar positioned herself as a pioneer in her field. Initially she spoke to a very small number of collectors who shared her personal pleasure for unique design. Indeed, as a collector herself, Yashar underlines that she is "always trying to make my passions become real through hard work and having fun. My goals have been to overcome the previous achievements, never laying back, and continually raising the bar of my activities as a gallerist towards a more and more curatorial approach."

The evolution of her aesthetic began with her Persian roots; her family moved to Italy when she was a child and her father had an interest in historical carpets. She followed in his footsteps and began dealing mainly in antique rugs from both the Middle and Far East, selling individual hand-selected pieces. Later embracing different aesthetics, she describes "adding historical design pieces: Scandinavian first, then Italian, and lastly Brazilian, and then also contemporary design." The object that first brought her to design was in fact a Swedish carpet, which triggered a journey to Scandinavia where she fell in love with vintage Scandinavian pieces; this was compounded by a wardrobe designed by Alvar Aalto for the Paimio Sanatorium—henceforth, the future of Nilufar grew exponentially.

Alongside the gallery in Milan, Yashar has taken part in fairs internationally, from Paris's Pavillion des Arts et du Design to Design Miami, Design Basel, PAD London, and New York's Salon Art + Design. Most recently, she opened Nilufar Depot, a 1,500-square-meter (4,921-square-foot) warehouse north of the Garibaldi train station. An ex-industrial space modernized by architect Massimiliano Locatelli, it is now a three-story treasure trove of more than 3,000 pieces. The central atrium has a cement floor, which is surrounded by black metal balconies and features a stage with a six-meter-tall brass curtain by Portuguese artist Leonor Antunes. For Yashar, "it is more and more evident that the new directions of design seem ▶

(*Right*) The red walls and dark ceiling of this room make it moody and glamorous, the warm bamboo bed contrasting with brushed metal on the lamp and side table, and the fabric chair by Massimiliano Locatelli.

Material and texture combine in this interior, which uses bamboo ceiling lights and screens by Osanna Visconti di Modrone, chairs by Massimiliano Locatel and hand-blown vases by Domitilla Harding (*pages 172–173*).

"I'M ALWAYS TRYING TO MAKE MY PASSIONS BECOME REAL."

In this richly opulent room, bathed in contrasting colors of red and green, chairs from Khaled El May's Flora collection are offset by Yoki hand-blown glass sculptures by Claude Missir, and tables designed by Nucleo featuring Hilario Isola (*above*).
This wooden cabinet by Bethan Laura Wood comprises 2000 pieces of laminate-marquetry-covered birch ply with wedge tongue detail and powder-coated steel. The lights are from her *Criss Cross* collection, colored glass used to mesmeric effect (*right*).

NINA YASHAR

Purple 1960s velvet armchairs by Osvaldo Borsani beautifully offset red velvet curtains that drape to the floor (*below*).

Bethan Laura Wood has a passion for color and detail, both of these elements can be felt in these opulent lights called Branches, featuring multi-colored Plexiglass shapes akin to verdant leaves (*right*).

"MY GOALS HAVE
BEEN TO OVERCOME
PREVIOUS ACHIEVEMENTS,
NEVER LAYING BACK,
AND CONTINUALLY RAISING
THE BAR."

▶ to lead to formal results that stand out from functionality, breaking the modernist dogma of form follows function." In other words, hybridizing art and design makes "the former more experimental and the latter more accessible."

The overarching direction of the gallery is to keep an open mind and remain in conversation with a changing world, not getting caught up in present styles or reiterating old schemas. "I could never stick to a set direction as I'm always curious and thinking outside of the box," she says. Her career highlights include the recent exhibition about Lina Bo Bardi, an Italian architect, designer, scenographer, editor, and illustrator who joined the Italian resistance in the Second World War and ended up in Brazil. The iconic is combined with the everyday in Bo Bardi's furniture, each piece built for a specific purpose. Yashar emphasizes that the show was backed up by "scientific content and archival research," combining design objects with a sense of their historical significance and context.

In terms of upcoming young talent championed by Yashar, she cites Amsterdam-based studio Odd Matter, which has created a series of lights that turn the line drawings of electrical diagrams into a three-dimensional form, rotating arms completing loops of copper to reach illumination. Similarly, Audrey Large is a French designer based in Maastricht whose research-based practice produces futuristic sculptures that travel between the digital and physical space in a slippage between image and object that acknowledges a digital reality.

Unsurprisingly, Yashar curates her own home with exactly the same approach she takes at the gallery: "I [always] try to stage dissonances to highlight the value of each piece and at the same time this results in the creation of an unexpected harmony." For more than 20 years, she has lived in a 250-square-meter (820-square-foot) Milan apartment that is surrounded by flower-laden roof terraces. The space mixes pieces from mid-century Carlo Mollino chairs and Victorian candlesticks from 1850 to handmade Iranian rugs. Yashar commissioned the jewelry designer Giancarlo Montebello to use a fresco technique with natural pigments and gold leaf to decorate the ceilings, which rise above wall engravings with Indian motifs from the sixteenth century. Her closet uses fabric given to her by Miuccia Prada that was originally used for an event in Paris and then repurposed thereafter. Yashar describes Prada as both a role model and inspiration: "She is a great woman and dear friend, a wise manager driving innovation; cultivated and farsighted." Indeed, like at Prada, fashion, art, culture, and design meet in the work of Nina Yashar, the crossover between such worlds enabled by her curious eye that can never quite be satisfied. ◆

At the private club Chez Nina, an Asta Chandelier by Vibeke Fonnesberg casts a green glow over this round table by Joaquim Tenreiro, made in Brazil in the 1960s (*above*).

Chez Nina's multi-colored scallop-shell velvet seating is complemented by this Asta Quadro ceiling lamp by Vibeke Fonnesberg, which this time casts a mood of red in this luxuriant space for relaxation (*right*).

A CHAMELEON'S DREAM

This particular scheme has a limited palette of green, blue, yellow, and orange. Tones are harmonious and shades often identical from one piece to the next. The beds and seating furniture have been reupholstered in plain woolen fabrics to complete the homogenous look.

PARISIAN APARTMENT
PARIS, FRANCE
DESIGNER & RESIDENT
FLORENCE LOPEZ

Here's a riddle: how does one live in 18 different apartments in 25 years without ever moving home? Answer: meet antique dealer and interior designer Florence Lopez, whose Parisian abode doubles as her workplace. With her finger on the pulse, Lopez creates a new look for the place every two to three years, inviting her clients (among them actors Gérard Depardieu and Charlotte Gainsbourg) to buy into the lifestyle she creates for herself.

The apartment occupies the top floor of a seventeenth-century building on Rue du Dragon, and was originally a sculpture studio added to it in the 1920s. Blackened floorboards and sloping ceilings lend a distinct atelier vibe to the place, while a run of large windows overlooks the street. Styling the entire apartment according to a particular theme—whether it is European arts and crafts or Japanese Zen—Lopez's artistry lies in selecting pieces that work in unison in terms of shape, scale, form, and color. For example, take this current theme: a homage to the Brazilian landscape architect and artist Roberto Burle Marx. Central to the scheme is a large mural based on a tapestry by the artist. The painting is an abstract design of curvaceous forms in blues, greens, and yellows. Cast your eye around the studio and you will see the shapes and shades echoed in three-dimensional form in the 1950s sofa by Adrian Pearsall, the Arne Norell tufted armchair, and even in the floral upholstery of a Bergère chair.

Layer by layer, Lopez carefully builds each corner of the room right down to the smallest ornament. And although her wares span centuries of furniture design, Lopez finds herself returning time and again to mid-century modern. In this particular scheme, beside the seating in the studio room, is a daybed designed by George Nakashima; in Lopez's bedroom is a Charlotte Perriand daybed, above which shelving by Gio Ponti graces the striped walls; and in the kitchen is an Osvaldo Borsani dining table. Elsewhere there is a Carlo Mollino lamp, an Alvar Aalto chair, a table by Giuseppe Scapinelli, a bookcase by Vittorio Dassi, a chandelier by Luigi Zortea— the list goes on. ◆

182

Although her wares span centuries of furniture design, Lopez finds herself returning time and again to mid-century modern.

Among the furnishings in the bedroom (*left*) are a small orange-painted plywood chair by Alvar Aalto, a wood lamp by Lisa Johansson-Pape, and two bookcases by Gio Ponti.

185

Roberto Burle Marx made the tapestry upon which this mural is based (*above*) in 1969. Its curvaceous lines capture the organic forms that epitomize the dominant style of mid-century modern.

WITH HER FINGER ON THE PULSE, LOPEZ CREATES A NEW LOOK EVERY TWO YEARS.

189

PARK AVENUE APARTMENT
NEW YORK CITY, USA
DESIGNER KELLY BEHUN STUDIO

THE HEIGHT OF SOPHISTICATION

The exquisite styling of this Park Avenue apartment is the work of New York-based Kelly Behun. Highly skilled in designing luxury homes for her prestigious clients, Behun crafts sophisticated spaces that ooze understated opulence. Rather than creating rooms with a particular theme or style, Behun's interest lies in cultivating a look that has a striking visual impact but also resonates on an emotional level.

Each room in this apartment has one or two standout features around which the rest of the decor revolves. In the entrance, Porter Teleo's hand-painted wallpaper provides the perfect backdrop for a wall sculpture by Rana Begum and a vintage Pablo Picasso rug; in the library, a stunning gold-leaf ceiling shines all the more brightly above royal blue-lacquered walls; and in the main bedroom, a sky blue hand-painted wallpaper by Gracie features tree motifs, echoes of whose colors are found in all the room's furnishings—soft grays, ivories, and fluffy whites.

Many of the rooms are laid with narrow strips of white oak, sometimes layered with rugs and carpets in rich textures; bold patterned wallpapers line other rooms. It is against such highly charged backdrops that Behun effortlessly sets works from different eras to achieve a unified whole: a pair of Josef Hofmann chairs in the library, a suite of Charlotte Perriand chairs around the dining table, a side table by Méret Oppenheim in the living room, a Campana Brothers chair in the main bedroom, and Joe Colombo's fabulous Tube chair in the family room. ◆

PARK AVENUE APARTMENT

SKILLED IN DESIGNING FOR
PRESTIGIOUS CLIENTS,
BEHUN CRAFTS SOPHISTICATED
SPACES THAT OOZE
UNDERSTATED OPULENCE.

Several elements in this apartment are custom-made: the banquettes and backgammon table in the library (*pages 192–193*), the banquettes and rug in the living room, the Lindsey Adelman light fitting in the dining room, and a desk in one of the guest rooms (*page 197*).

195

198

ITALIAN PAD
SAN VITO DI LEGUZZANO, ITALY
DESIGNER GIACOMO TOTTI
RESIDENTS
FILIPPO CRIVELLARO &
SHAKHNOZA MAKHMEDOVA

BOLD MIX AND MATCH

If there is one thing Italian architect Giacomo Totti truly excels at, it is his skill in achieving the most delicate juxtaposition of color, texture, and pattern. Take his styling for this home in San Vito di Leguzzano—a European base for a professional couple who work in international development and divide their time between Italy and Central Asia.

The dominant color scheme centers on just two basics throughout: red and blue, albeit in subtle shades of which echoes can be found in each room. For example, the teal of the kitchen cupboards also graces the bedroom walls, while a darker shade takes shape on a feature wall in the living room, lines the stairs from one floor to the next, and is the color of the bathroom tiles. Each of the rooms has the same salmon pink drapes, while other "reds" feature in the lilac upholstery of the dining chairs and ruby red shades in the living room.

When it comes to texture and form, the fronds of the palms in the living room are mirrored in the design of the ceramic plant pots and resonate in the etching of the bathroom tiles, the stunning turquoise ceramic "scales" that dress the living-room fireplace are reminiscent of the sprays of eucalyptus dotted around the house, and the bed is layered with tactile leather, satin, silk, and cotton textiles. For the most part, colors are flat, without decoration or ornament, so present the finest backdrop for Totti's bold patterned elements, which take shape in the exotic jungle wall hanging in the bedroom and the abstract snake curled up on the living-room floor. ◆

Giacomo Totti stands beside the fireplace in the living room. Even he is in harmony with the color scheme that dominates his styling of the house, in deep red and midnight blue—right down to the swirling, mythical designs of his tattoos.

ITALIAN PAD

Totti is a great fan of greenery. All of his rooms feature foliage, which mostly takes shape as exotic palms or sculptural cactuses. Along with the patterned textiles, they add a dynamic edge to the spaces, preventing them from looking too minimalist.

ITALIAN PAD

TOTTI EXCELS AT HIS
SKILL IN ACHIEVING THE
MOST DELICATE
JUXTAPOSITION OF COLOR,
TEXTURE, AND PATTERN.

DIMORE

The refined elegance
that Dimore Studio brings
to spaces by blending old and
new objects and styles
has helped usher in the next
era of Italian design.

STUDIO

205

DIMORE STUDIO

"Carlo Scarpa, Gio Ponti, Piero Portaluppi, Gabriella Crespi, Osvaldo Borsani"—Dimore Studio founders Emiliano Salci and Britt Moran reel off a list of Italy's most prominent and celebrated twentieth-century designers when asked who has been influential to their work.

Italy, and particularly Dimore Studio's home city of Milan, is synonymous with glamor. Lauded as a design and fashion capital—a reputation built with the help of Scarpa, Ponti, and the others—the country's northern powerhouse has been looked to as a barometer for taste, style, and elegance for centuries. However, its economy was hit heavily by the 2008 financial crisis, and the design industry suffered as a consequence. Although the fashion weeks and Salone del Mobile—Milan's annual furniture fair—continued brazenly, the dominance of Italian design was slightly diminished as other nations recovered faster. But, particularly in the past few years, the rise and resurgence of the country's practices, brands, and institutions has returned the design mecca to the top of the pile—and Dimore Studio has arguably led the charge.

"WE CREATE SPACES THAT HAVE A SENSE OF HISTORY, WITHOUT BEING RECREATIONS OF HISTORY."

Native Italian Salci, and Moran, an American, founded Dimore Studio in 2003, coming to specialize in residential and commercial interior projects. They have since completed stores for luxury brands Fendi, Hermès, and Aesop, hospitality spaces on multiple continents, and private residences with historic bones or new canvases. Each project is markedly individual through the colors, soft and hard furnishings, and range of materials used, yet all are easily identifiable as being created by the same hand, or hands. "Our ideas stem from a concept, from different sources of inspiration that adapt and evolve to create an experience, a 'world' [that is reminiscent of] an era, which is then contaminated, infiltrated by other influences," says the studio.

Using their stamp, the duo has managed to build a client base that allows them to flex their design muscles and exercise their aesthetic across the various spatial typologies. Although there are subtle differences between the approach to these—more furniture is used in the residential projects, for example—the mood is undoubtedly sultry and seductive across the board. An elevated, more decorative appearance than that created by their modernist predecessors, but always with the same attention to detail.

Through its work, Dimore Studio channels the opulence of Italy's heyday with a flair to rival the icons they revere. But their real success revolves around achieving this while simultaneously ensuring their projects feel fresh, contemporary, and unique. By blending luxurious, tactile fabrics with cold sheets of metal, or pairing curtain-wrapped walls with stark light-box flooring, Dimore Studio finds a middle ground that celebrates both old and new. "The trademark style of Dimore Studio's work is that of a design practice constantly moving between design, art, architecture, and fashion," says the duo. "It is a widely recognized vision in that it allows the coexistence of different materials and different periods, a constant dialogue between past and present, tradition and contemporaneity, so to create and shape a specific atmosphere in every project." ▶

Dimore Studio merged rich colours and textures for the Palazzo Privè Fendi in Rome, from the wine-red rug to the chairs combining cold metal with warm crocodile leather (*right*).

From the patterned ceiling to the engraved wooden fireplace, the original features of this Viale Jenner Apartment in Milan have been enhanced with a combination of ceramic, metal, leather, glass and wooden objects (*pages 208–209*).

207

210

DIMORE STUDIO

"WE START
FROM
A THOUGHT,
A MOOD,
TO WHICH
WE HAVE
BEEN DRAWN—
IT CAN BE
AN OPERA,
A MOVIE, AN
EXHIBITION."

—

► This is nowhere more apparent than in their own gallery on Via Solferino, where the rich colors and highlighted original features unfold room after room, creating a series of unique exhibition spaces. Set up a few years after beginning the studio, Dimore Gallery was created by Salci and Moran to sell vintage and contemporary designs, which are displayed side-by-side in styled vignettes.

For many projects, their inspiration stems from a precedent—be it the Paimio Sanatorium by Alvar Aalto or the pantry at Portaluppi's Villa Necchi Campiglio—then branches out as they add layers of "unusual and unexpected" colors and materials. "We create spaces that have a sense of history, without being recreations of history," Dimore Studio says. "[We] give them roots that people can identify with, whilst making the space contemporary and up-to-date through the use of colors and materials that reflect today. Our design process starts from a thought, a mood, to which we have been drawn—it can be an opera, a movie, a fashion show, an exhibition. We then develop it, make it ours, by adding new things to it, new ideas."

In April 2019, the duo launched Dimore Milano, their own furniture, lighting, and homeware brand. For its debut presentation, titled Interstellar, the designers transformed Milan's old Cinema Arti to demonstrate "the evolution of Britt Moran and Emiliano Salci's galaxy." The products echo the signature aesthetic that Dimore Studio has carefully crafted with its succession of interior projects, as well as through the gallery, but with an even more contemporary direction via the use of lacquers, brushed and polished steel, bronze, and laminated surfaces. "From when we first started, the underlying feel, our DNA, is the same, perhaps more profound," the designers say.

With the launch of Dimore Milano, Dimore Studio has positioned itself at the head of a new generation of Italian designers who are building on the country's rich heritage to create a new movement rivaling that of Scarpa's era. Salci and Moran's presentations during the Salone del Mobile are always eagerly anticipated, and their ever-expanding portfolio of projects proves that they have become the go-to studio for the sumptuous interiors that have become so desirable of late. Dimore Studio's fervor and finesse, particularly for this style, have undoubtedly helped Italian design reclaim its superiority. ◆

212

The monochrome patterned walls of this Saint Germain Apartment in Paris at once recall the motifs of the ancient Aztecs and the funk of the 1960s (page 210).

Wild animals from leopards to monkeys roam upon the bedroom curtains of this Saint Germain Apartment, contrasting with the more formal geometric pattern of the wallpaper (above).

The living room of this Saint Germain Apartment combines plant-print curtains with a palm-tree-style lamp, while another central light piece recalls illuminated branches (right).

The seventeenth-century Palazzo Privé Fendi in Rome has original details including decorative stucco on the doors and floors, painted a blue-grey shade that Dimore Studio mixed themselves (page 214).

Shape and texture define this Viale Jenner Apartment in Milan, from the circles on cabinets and rectangles on doors, to the complementary surface materials of metal, wood and marble (page 215).

214

215

VILLA BORSANI
MILAN, ITALY
DESIGNER CAMPBELL-REY

BORSANI'S VISION REVISITED

Taking a tour of Villa Borsani—the rooms arranged by Campbell-Rey creative consultancy—it is incredible to think that the original styling is just 20 years shy of a century old. The work of celebrated Italian designer Osvaldo Borsani, completed in 1943, the house is one of the iconic designs of the mid-century modern era. While embracing the Gesamtkunstwerk concept of the art nouveau and art deco periods, the design is resolutely rationalist, with large open-plan rooms, sweeping vistas, and floor-to-ceiling windows—all hugely avant-garde at the time.

Rooms are filled with pieces Borsani designed himself, many of them custom-built, and foreshadow the sleek lines and technical mastery of the modern age. Central to the house, for example, is a three-tier staircase with marble steps and a walnut handrail that seems to float above almost invisible glass panels. This styling by Duncan Campbell and Charlotte Rey is an exercise in color, texture, and form: a checkered cushion in the study mirrors the geometric layout of the parquet floor, towels in the bathroom are carefully selected to match the color and patterning of the walls and floor, and in the dining room, Borsani's exquisite onyx table is dressed with stunning glassware in amber and indigo. Throughout, colors range from rich topaz and violet through to gold and cinnamon. And yet, so subtle are Campbell-Rey's touches that, instead of competing with Borsani's originals, they complement them and only serve to emphasize the timelessness of their design. ◆

217

VILLA BORSANI

THROUGHOUT, COLORS RANGE FROM RICH TOPAZ AND VIOLET THROUGH TO GOLD AND CINNAMON.

———

WHILE EMBRACING
THE GESAMTKUNSTWERK
CONCEPT OF THE ART
NOUVEAU AND ART DECO
PERIODS, THE DESIGN
IS RESOLUTELY RATIONALIST.

—

From the luxuriant textiles and soft furnishings to props that include house slippers, ashtrays, and a pair of spectacles, Campbell-Rey's additions to the styling of Villa Borsani are so convincing that you might think you have stepped back in time.

VILLA BORSANI

BORSANI'S EXQUISITE
ONYX TABLE IS
DRESSED WITH STUNNING
GLASSWARE IN
AMBER AND INDIGO.

227

HAVE NOTH
HOUSE THAT
OR BEAUTIFU
RULE WERE
OUT, YOU
ASTONISHE
AMOUNT OF
WOULD GET

...NG IN YOUR ...S NOT USEFUL ...L; IF SUCH A ...FOLLOWED ...WOULD BE ...D AT THE ...RUBBISH YOU ...RID OF.

—Oscar Wilde

PURE
PIETRO
RUSSO

PIETRO'S HOUSE WORKSHOP
MILAN, ITALY
DESIGNER PIETRO RUSSO DESIGN
RESIDENT PIETRO RUSSO

Russo has a diverse assortment of paintings, vases, and miniatures collected over time. Many objects and ornaments are inspired by nature, including a series of nineteenth-century engravings related to biology, a collection of wooden utensils, and a shoal of "flying fish" in the hallway.

Milan-based interior designer Pietro Russo sees himself as a tailor for his clients. By getting to know them, the service he provides is all the more suited to their whims, passions, and desires, albeit through his design eye. On this occasion, the client is Russo himself and the space is an apartment within the 1930s building that also houses his studio. As such, the interior sees the culmination of the elements that make Russo's styling so unique. The curious combination of nature-inspired and space-age elements contributes to a style he has dubbed "exotic futurable." His passion for nature manifests in a preference for wood as a material, and in the serene color schemes that see brown married with green or light blue—soft earth, sky, and sea colors. There is also an abundance of foliage.

Almost all of the furnishings are Russo's own designs: neat wooden drawers, shelving raised on narrow spindles, and his Alma dining table. Up above, and counting among the more space-age elements, are light fittings from his Sat, Drone, and Libra collections—elegant brass-enrobed disks and glass tubing. A wonderful lightness of touch is epitomized by the two-sided Romboidale bookshelf that doubles as an elegant and airy space divider. In the living area, a Gebrüder Thonet Vienna sofa and armchairs, with their cane frames and dusky pink upholstery, add an unexpected colonial touch. Dotted around the place, and bringing the diverse themes together, are the ornaments Russo has stumbled across in street markets over the years—a collection he refers to as his "archive of inspiration of unnecessary things." ◆

234

THE CURIOUS COMBINATION OF NATURE-INSPIRED AND SPACE-AGE ELEMENTS CONTRIBUTES TO A STYLE RUSSO HAS DUBBED "EXOTIC FUTURABLE."

From the exquisite display cabinet in the kitchen (*below*) to the open shelving that divides the space and the elegant console table in the hallway (*page 233*), Russo's sleek, minimalist furniture designs have a timeless quality to them.

Russo has done much to maintain the original internal structure and styling of his apartment, polishing the existing terrazzo floors in the open-plan living/kitchen area and smoothing plaster on the walls before giving it a new coat of whitewash.

PIETRO'S HOUSE WORKSHOP

Almost all of the furnishings are Russo's own designs.

MAGICAL MONSTER MIX
JUTLAND, DENMARK
DESIGNERS & RESIDENTS
METTE HOLM & LARS NIELSEN

MAKING NEW, USING OLD

Monsterscircus blogger Mette Holm is considered one of Europe's most established interior design influencers. Passionate about styling domestic spaces—not least those in her own home in Jutland, Denmark—her creative energy knows no bounds. Central to her work, which is best described as a fusion between art deco, Memphis, and historicism, is a deep-rooted interest in recycling: "I'm not blogging about buying the right things—but more about how to resolve renewal within the home," she says. "I wish to use already existing materials, and am happy every time I 'invent' new, using old." It is a maxim that has seen Holm fashion a glass totem pole from colored vases and bowls, and a mobile from Christmas tree decorations.

Particularly characteristic of Holm's knack for purposeful reinvention are the highly original treatments that grace the walls of her home. For example, one corner of the living room features a series of stylized overlapping Gothic arches painted in soft beige, petrol blue, and cinnamon red. On one wall of the upstairs reading room, a collection of painted geometric shapes mirrors the arrangement and muted colors of cushions piled on the sofa. And in the living room, a three-dimensional collage of blankets, fur, and brass dishes creeps up the wall between two windows and onto the ceiling. When it comes to furnishing the rooms, Holm offsets them with simple, classic pieces that include a teak dining table paired with Arne Jacobsen's Series 7 chairs. ◆

On the ground floor, the main room is divided into three areas: living, dining, kitchen. Bold elements such as the Gothic-arch wall art (*opposite*) and leaf-print rug (*above*) are offset with surfaces in more muted tones, such as the gray sofa and carpet.

A classical kitchen design has been up-cycled with lighting from Grupa, oversize tiles from Evers, and oak tabletops. A pink glass lamp hangs from above, beside an abstract wood and metal sculpture. The stools are by Finnish designer Sami Kallio.

MAGICAL MONSTER MIX

"I WISH TO USE ALREADY EXISTING MATERIALS, AND AM HAPPY EVERY TIME I 'INVENT' NEW, USING OLD."

Ice cream colors in the dramatic wall art find expression elsewhere in the room—in the pink ceramic lamp with brassy shade (*above*) and in one of Holm's glass totem vases, for example.

MAGICAL MONSTER MIX

243

MILAN TODAY APARTMENT
MILAN, ITALY
DESIGNERS & RESIDENTS
PIER LOMASCOLO & FIGUE UYAR

CURVES, COLORS, AND SHAPES

Within the generous rooms of this 1960s Milan property, creative couple Pier Lomascolo and Figue Uyar found the ideal setting in which to make their own contribution to the style revival currently underway in the Lombardy capital. The project marked a return to the city for Lomascolo, who, Milanese by birth, had spent decades away: "It was this moment of Milanese Renaissance that brought me back," he says. "This is a very different city from the one I left at 18 years old. Even the skyline has completely changed."

Relaxed in their approach, the couple allowed the spaces to develop naturally. Central to their design are the original marble-slab floors the couple found languishing beneath retrofitted parquet. Though worn and disjointed, the couple retained the marble, encasing it in a glossy lacquer through which the marble patterning remains discernable. It serves as a perfect stage on which to set the eclectic mix of predominantly Italian iconic 1930s and 1960s furnishings.

No matter what period the pieces, the overall look is unified by Lomascolo's desire to focus on "curves, colors, and a massive organic presence." The curves can be found in the limited-edition Geo sofas by Saba and in a three-dimensional wood-paneled wall by Wood—Skin in the dining room.

A sophisticated palette of colors includes sage green and cerulean blue, as well as a range of gold and bronze tones, while the organic element lies in the plethora of foliage—from a cascade above the bespoke kitchen to the "undergrowth" in the living area.

The rooms in the apartment feature an eclectic mix of furnishings that include family pieces from the 1930s, objects collected through many travels, and contemporary furniture, especially that of Italian designers.

THE OVERALL LOOK IS UNIFIED BY LOMASCOLO'S DESIRE TO FOCUS ON "CURVES, COLORS, AND A MASSIVE ORGANIC PRESENCE."

248

RELAXED IN THEIR APPROACH, THE COUPLE ALLOWED THE SPACES TO DEVELOP NATURALLY.

A university lecturer, Uyar is French and Turkish, while Lomascolo, creative director and founder of his communication agency, is Italian and Spanish.

The subtle color palette finds echoes in all of the rooms, whether it be in the graphic design on the bedroom walls (*opposite*), the light fitting by Bocci in the dining room (*page 246*), the kitchen tiling (*left*), or the rich textiles and upholstery throughout.

A SOPHISTICATED PALETTE OF COLORS INCLUDES SAGE GREEN AND CERULEAN BLUE.

A

◆

JONATHAN ADLER
USA
PARKER PALM SPRINGS
jonathanadler.com
Pages 88–95
Photography: Courtesy of Parker Palm Springs

GREENWICH VILLAGE APARTMENT
jonathanadler.com
Pages 122–133
Photography: Richard Powers (Pages 6, 10, 122–133)

◆

DAVID ALHADEFF
USA
thefutureperfect.com
Pages 76–87
Photography: Douglas Friedman (Pages 9, 76–87)

◆

AMBER ROAD DESIGN
AUSTRALIA
POLYCHROME HOUSE
amberroaddesign.com.au
Pages 134–139
Photography: Prue Ruscoe

B

◆

KSENIA BREIVO
RUSSIA
MOSCOW MULTI-STORY
Pages 72–75
Photography: Kristina Nikishina

C

◆

CAMBELL-REY
UK
VILLA BORSANI
campbell-rey.com
Pages 216–229
Photography: Tinko Czetwertynski

◆

XIMENA CAMINOS
USA
LA CASA DE LAS FUENTES
Pages 98–111
Photography: Kris Tamburello

◆

CRISTINA CELESTINO
ITALY
cristinacelestino.com
Pages 12–23
Photography: Helenio Barbetta/Living Inside

D

◆

DIMORE STUDIO
ITALY
dimorestudio.eu
Pages 204–215
Photography: Andrea Ferrari (page 207–209, 214–215); Mai Linh (210, 212–213)

E

◆

ESTER BRUZKUS ARCHITEKTEN
GERMANY
ESTER'S APARTMENT 2.0
esterbruzkus.com
Pages 24–31
Photography: Jens Bösenberg

H

◆

METTE HOLM AND LARS NIELSEN
DENMARK
MAGICAL MONSTER MIX
Pages 238–243
Photography: Martin Solyst/Living Inside
Styling: Eva Marie Wilken

K

◆

KELLY BEHUN STUDIO
USA
PARK AVENUE APARTMENT
kellybehun.com
Pages 190–197
Photography: Richard Powers

L

◆

L. A. STUDIO
SPAIN
PASEO DE LOS LAGOS
lastudio.es
Pages 112–119
Photography: Belen Imaz

◆

PIER LOMASCOLO AND FIGUE UYAR
ITALY
MILAN TODAY APARTMENT
Pages 244–253
Photography: Robert Holden/Photofoyer

◆

FLORENCE LOPEZ
FRANCE
PARISIAN APARTMENT
florencelopez.com
Pages 180–189
Photography: Matthieu Salvaing

M

◆
MARCANTE-TESTA
ITALY
TEOREMA MILANESE
marcante-testa.it
Pages 62–71
Photography: Carola Ripamonti

◆
IRINA MARKMAN
RUSSIA
COLOR
Pages 54–59
Photography: Sergey Krasyuk

P

◆
PIETRO RUSSO DESIGN
ITALY
PIETRO'S HOUSE WORKSHOP
pietrorusso.com
Pages 232–237
Photography: Filippo Bamberghi

R

◆
REUNION GOODS & SERVICES
USA
OSBORNE BUILDING RESIDENCE
reunion.gs
Pages 154–157
Photography: Howie Guja
Additional Credit: Fogarty Finger (Architect)

◆
**ROLLMANN ARCHITECTURE
AND ANTHONY SPERDUTI**
USA
TRIBECA LOFT
rollmannarch.com
Pages 40–45
Photography: Gieves Anderson

◆
ROUGE ABSOLU
FRANCE
PARIS ÉTOILE
rougeabsolu.com
Pages 142–153
Photography: Rouge Absolu (pages 5, 142–153)

S

◆
ETTORE SOTTSASS
ITALY
CASA OLABUENAGA
Pages 158–163
Photography: Mariko Reed/OTTO

◆
STUDIO RHONDA
UNITED KINGDOM
YORK WAY
studio-rhonda.com
Pages 164–167
Photography: Rachael Smith Photography

T

◆
GIACOMO TOTTI
ITALY
ITALIAN PAD
giacomototti.com
Pages 198–203
Photography: Helenio Barbetta/Living Inside

◆
**GIACOMO TOTTI
AND ANDREA MAINO**
ITALY
THE SHOE FACTORY
giacomototti.com
Pages 46–53
Photography: Helenio Barbetta (Pages 8, 46–53)

W

◆
SOPHIE WANNENES
ITALY
PalermoUno
Pages 32–37
Photography: Monica Spezia

Y

◆
NINA YASHAR
ITALY
nilufar.com
Pages 168–179
Photography: Nilufar Gallery

THE HOUSE OF GLAM

LUSH INTERIORS
&
DESIGN
EXTRAVAGANZA

THIS BOOK WAS CONCEIVED, EDITED, AND DESIGNED BY GESTALTEN.

EDITED BY ROBERT KLANTEN AND ANDREA SERVERT

PREFACE BY CLAIRE BINGHAM

PROJECT TEXTS BY ANNA SOUTHGATE

PROFILES BY DAN HOWARTH (DIMORE STUDIO AND DAVID ALHADEFF) AND LOUISA ELDERTON (NINA YASHAR AND CRISTINA CELESTINO)

EDITORIAL MANAGEMENT BY ADAM JACKMAN

DESIGN BY STEFAN MORGNER AND ILONA SAMCEWICZ-PARHAM

LAYOUT BY STEFAN MORGNER

TYPEFACES: TRAVIATA BY JÉRÉMY SCHNEIDER AND VIOLAINE ORSONI; WIGRUM BY ANOUK PENNEL AND RAPHAËL DAUDELIN; DOMAINE TEXT BY KRIS SOWERSBY

COVER PHOTOGRAPHY BY ROUGE ABSOLU

PRINTED BY PRINTER TRENTO SRL., TRENTO
MADE IN EUROPE

PUBLISHED BY GESTALTEN, BERLIN 2019
ISBN 978-3-89955-982-8

2ND PRINTING, 2021

© Die Gestalten Verlag GmbH & Co. KG, Berlin 2019

All rights reserved. No part of this publication may be reproduced or transmitted in any form or by any means, electronic or mechanical, including photocopy or any storage and retrieval system, without permission in writing from the publisher.

Respect copyrights, encourage creativity!

For more information, and to order books, please visit www.gestalten.com.

Bibliographic information published by the Deutsche Nationalbibliothek.
The Deutsche Nationalbibliothek lists this publication in the Deutsche Nationalbibliografie; detailed bibliographic data is available online at www.dnb.de.

None of the content in this book was published in exchange for payment by commercial parties or designers; gestalten selected all included work based solely on its artistic merit.

This book was printed on paper certified according to the standards of the FSC®.

MIX
Paper from responsible sources
FSC® C015829